Robert Breer

Art as attitude

vs.

Engineering as same.

Science? Engineering

Art	
female?	male?
open	closed
anti-authority	pro-order
forms	formulas
problems	solutions
questions	answers
aesthetic	pragmatic
politically engaged and/or aloof	neutral or subservient
metaphoric	objective
analog	digital
better	worse

" you're drunk, I'm relaxed "

Engineers Vs Artists

Engineers	Artists
fundamentals	peripherals
power	weakness
seriousness	frivolity
responsibility }	superficiality
heaviness	lightweightness
order	anarchy
maleness	formlessness
science	intuition
intelligence	(uninformed)
modesty	cleverness
conviction	presumptiousness
provenness	arrogance
essential	arbitrariness
primary	non-essential
	secondary

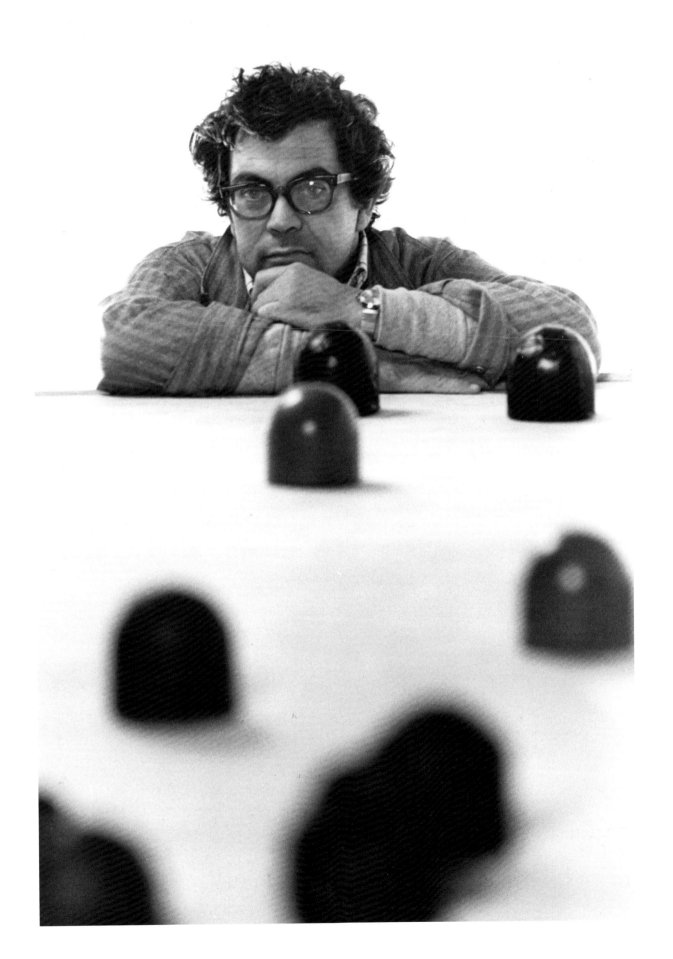

Robert Breer

BALTIC Centre for Contemporary Art, Gateshead
Museum Tinguely, Basel
2011

ein kulturengagement von roche

KERBER ART

Untitled, 1969
Pencil on paper
26.2 x 32 cm

Directors' Foreword

There is an exquisite unity in Robert Breer's work that enables the disparate elements of our physical, conceptual and aesthetic experiences to be understood as part of a single entity. Always aware of and engaged with the experimentation of the avant-garde, Breer associated with such luminaries as Marcel Duchamp and Le Corbusier, Jean Tinguely and Naum Gabo, yet his own character and perspective have remained both critically engaged and profoundly distinct for many decades.

His subtlety in inferring movement with the inanimate, or the static through almost imperceptible motion, engages the viewer in a way that is both perfunctory and profoundly universal – and he does all this with a restless and affirming optimism. It is for these reasons, amongst many others, that BALTIC Centre for Contemporary Art and the Museum Tinguely are delighted to be able to bring together this remarkable body of work, covering more than sixty years of the artist's practice and creating Breer's largest retrospective to date.

It is with great pleasure that our two institutions are able to collaborate on this venture. We offer our sincere thanks to colleagues in both organisations, and congratulate co-curators Laurence Sillars, Chief Curator of BALTIC, and Andres Pardey, Deputy Director of the Museum Tinguely, for representing Robert Breer's practice so comprehensively and with such lucidity. Their work is further enhanced in this publication by a text from Ute Holl, for which we are grateful. In the UK, we thank the Henry Moore Foundation for its generous support of the exhibition; in Switzerland, Roche, for its continued support and financing of the Museum Tinguely. Naturally, we cannot overstate our appreciation of the generosity of the lenders, both public and private. It is due to their kind support that the exhibition is able to be so comprehensive. Nathalie Boutin and Solene Guillier at gb agency, Paris, have also been unstintingly helpful in very many ways.

Lastly and most importantly, we thank Robert Breer, who, along with his wife Kate Flax, has made this sizable project an enormously pleasurable and rewarding undertaking for all concerned.

Godfrey Worsdale
Director
BALTIC Centre for Contemporary Art

Roland Wetzel
Director
Museum Tinguely

Untitled, 1949–1950
Oil on canvas
65 x 81 cm

Composition aux trois lignes, ca. 1950
Oil on canvas
114.5 x 146 cm

Untitled, ca. 1950
Oil on canvas
164 x 133.5 cm

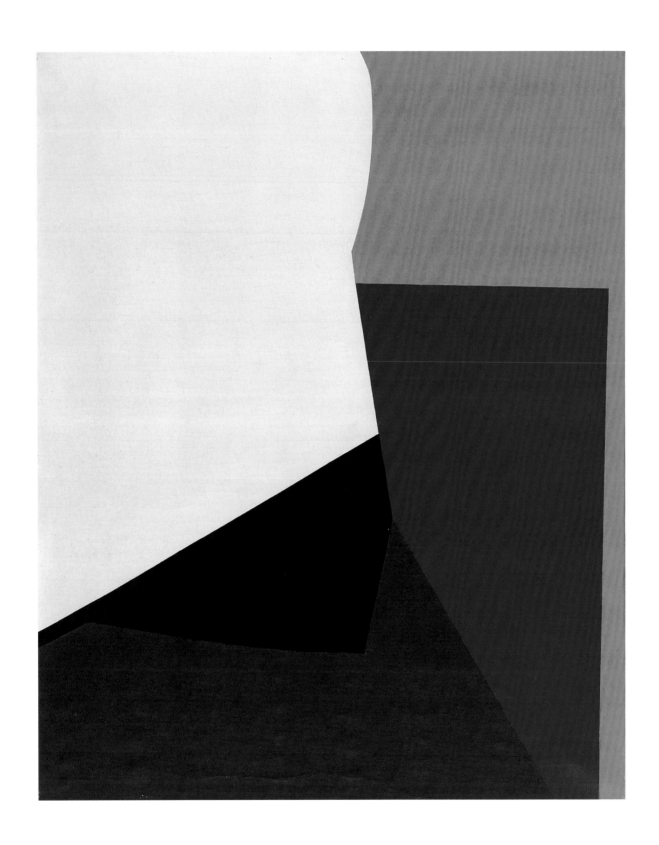

Untitled, 1952
Oil on canvas
100 x 81 cm

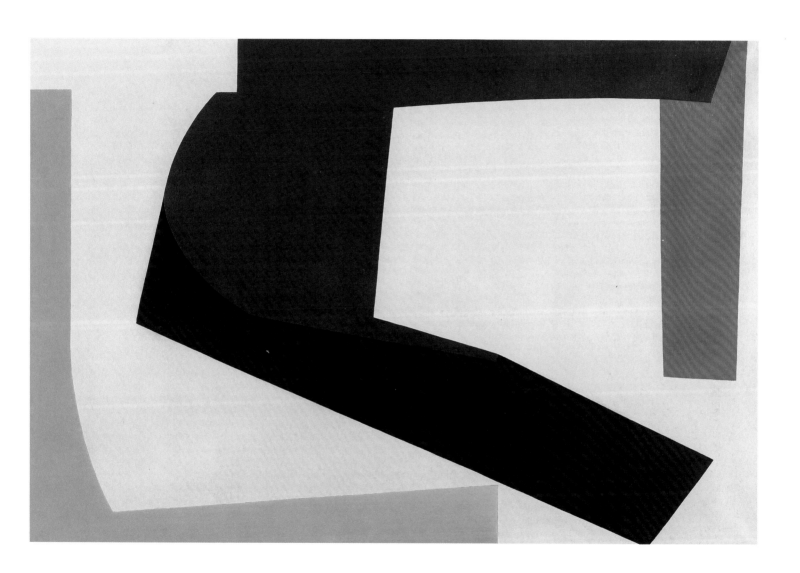

Untitled, 1952
Oil on canvas
89 x 131 cm

Paintings

After studying art at Stanford University, California, Breer moved to Paris in 1949 and continued the abstract painting he started at university. He had served in the military for two years and was able to subsidise himself in Europe through the U.S. Government GI Bill scholarship. During the ten years he spent in the French capital, he devoted himself to a style of painting that, in Europe, was labeled 'abstrait construit' or 'Neo-plasticism', and in America 'hard-edge abstraction'. The other dominant styles adopted by artists at the time were figurative painting and *Informel*. The quest for a clear and pure painting style was a distinctive feature of Neo-plasticism. Breer was part of a circle of artists whose hub was the Galerie Denise René. In the sometimes heated debates about abstract art, important figures of the Parisian art world, such as poet and editor Louis Aragon, attacked abstract art. In turn, abstraction was defended by critics such as Michel Seuphor. The gallery, and René who had founded it in 1944, also played an important role. René showed Vasarely and Herbin of the 'abstraction froide' group, artists to whom Breer felt close in their search for an absolute, quasi-objective abstract art. He was attracted by the idea that 'it was possible to simplify and reduce expression to a potent sign language'.[1]

Breer was part of several group exhibitions at the gallery, and it was there that he met the young Swedish art historian, Pontus Hultén, who helped organise the 'Le Mouvement' exhibition at Denise René's in 1955. Breer also contributed to this exhibition, which in many respects marked the end of his career as a painter.

1 Robert Breer in: Billy Klüver / Julie Martin, 'Robert Breer, A Painter in Paris, 1949-1959', ex. cat., Galerie 1900–2000, Paris 1990, p. 16.

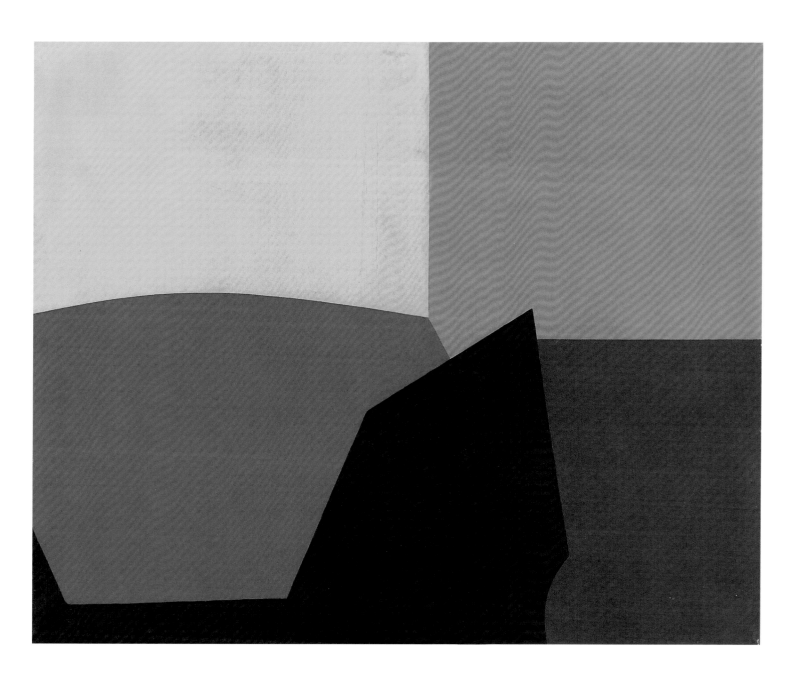

Untitled, 1952
Oil on canvas
81 x 100 cm

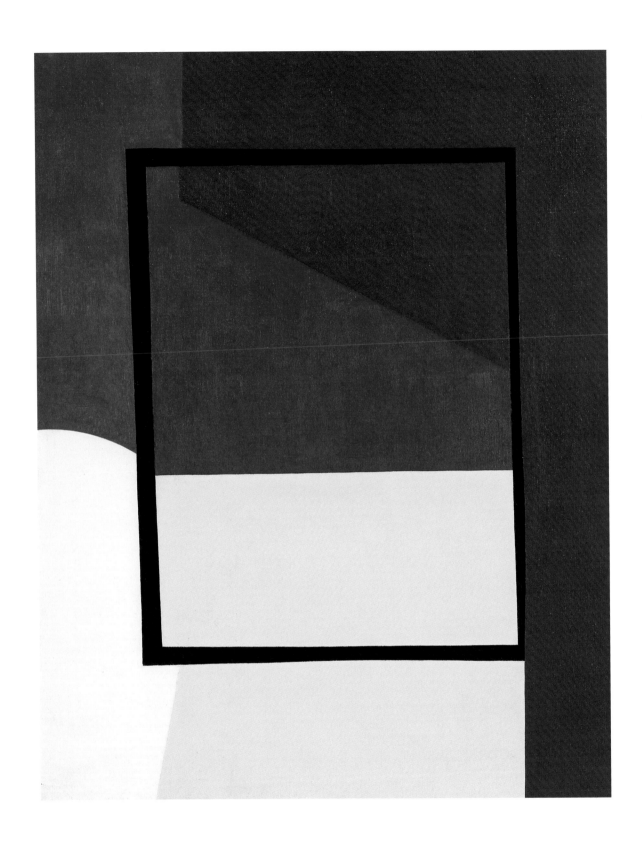

Time Out, 1953
Oil on canvas
92 x 64 cm

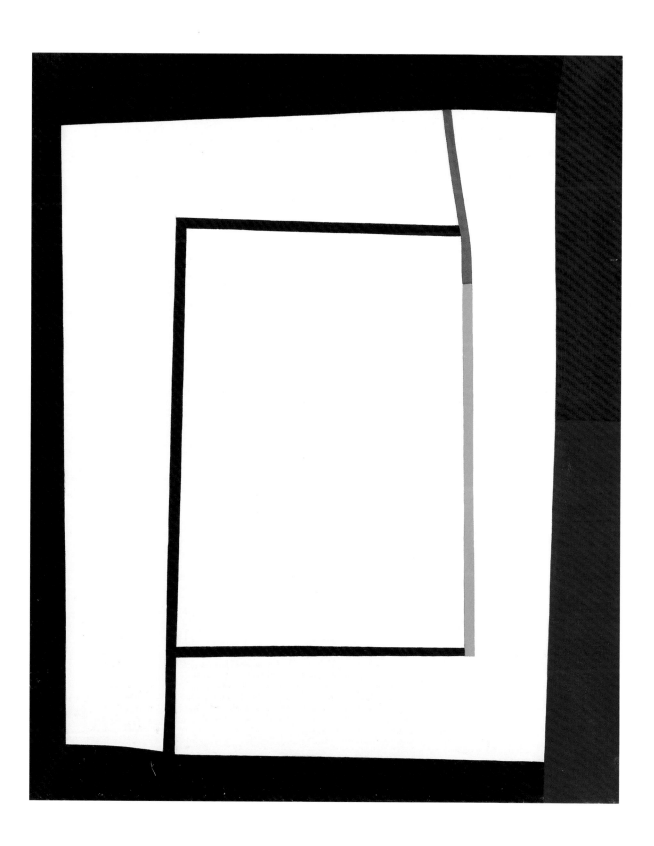

Untitled, 1953
Oil on canvas
100 x 81 cm

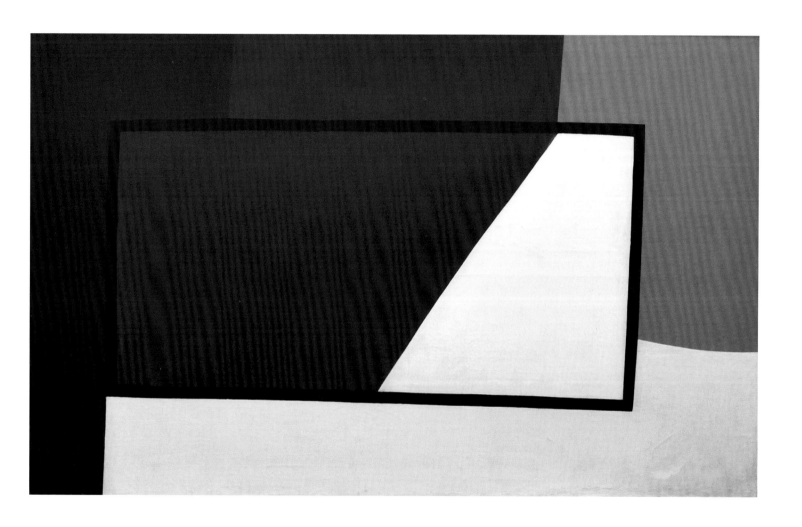

Untitled, 1953
Oil on canvas
81 x 130.5 cm

Time Flies

Laurence Sillars

'By jamming together and mixing both abstract and representative material, I find that I can satisfy my need to express both pure plastic sensation and ideas of ideational nature without compromising either. I believe that the fixed image is unable to serve this double purpose without the return to old and worn-out conventions.'

<div style="text-align:center">Robert Breer, 1957</div>

The apparent eclecticism of Robert Breer's art, spanning as it does painting, film, sculpture, and more, finds a parallel in his disparate beginnings. The son of an amateur 3D home-movie maker and chief engineer at the Chrysler Corporation, Breer was born in 'Motor City' Detroit in 1926. He studied engineering at Stanford, switching to fine art as a painter in his second year, and prior to that had been drafted into national service. Later he took up flying, having regular stunt lessons at the controls of a biplane; a signed copy of a book by fighter pilot and racing driver Eddie Rickenbacker is one of his most prized possessions. Form, design, speed and movement were all early concerns, and have continued to be driving forces in his work.

Breer was also exposed to art from a young age. Recognising his early abilities, even to draw a straight line better than him, his father sent him to art classes at the age of ten. Breer also recalls a family acquaintance who had an important art collection; Picasso, Klee and Matisse, in particular, had a profound impact on him. The most significant encounter, however, was during a college trip to San Francisco in 1947 when he discovered the work of Piet Mondrian. Breer, who until now had been a proficient figurative painter, was utterly seduced by the reductive purity of Mondrian's plastic, grid-based abstractions. He returned to college, abandoned representational painting and, just as Mondrian had after seeing Picasso's Cubism, was spurred to move to Paris, the city at the visual heart of his newly adopted discipline.

In France Breer soon found himself situated at the ideological fault-line between abstraction and representation. He began working with the Galerie Denise René amidst fellow disciples of Mondrian and the Bauhaus painters. René had been an early adopter of the first generation of abstract artists (Jean Arp, Alberto Magnelli, Auguste Herbin), and was by then showing their younger counterparts (Victor Vasarely, Jean Dewasne, Edgar Pillet) with similar alacrity. René often paired both generations of artists, contextualising the new with the old in exhibitions that maintained the linear tradition of art-historical progression dominant at the time. Breer remembers a 'built-in imperative for new (young) artists to do "the next thing!"'[1]

Although known primarily as an animator-filmmaker – indeed, as one of the most influential in history – Breer's experiences and mindset as a painter are significant. Ultimately they may be seen as an anchor to the structure of much that has followed. During his years in Paris he produced an expansive body of abstract painting. Each canvas typically employed three or four near, but never precise, geometric forms that established large blocks of flat colour. These 'clipped' shapes, with at least one irregular edge for each that was straight, switch back and forth between the appearance of tessellation and overlap. Curving, slanting, angled and cut-into, the

forms deny any overarching order or resolve. Instead, they fill the entire picture plane with a push and pull, shifting back and forth within an implied pictorial depth. Heavy black lines are periodically used to make open rectangular inner frames, or 'windows', forming a dialogue with the edge of the canvas in a further delineation of elastic space, or spaces. Yet these are demarcations that disrupt rather than promote unity, as did Mondrian's grid. They encourage the eye to view the complete canvas as a series of composites.

 Mondrian, looking first at the Parisian boulevard and then at the canvas, had called for both a redaction to and a reduction of disparate elements to create an absolute. In his enduring quest for aesthetic 'rest' and transcendental purity he spoke of '*fragments* of the particular', believing that '*[p]lastically* seen, everything fuses into a single image of colour and form'.[2] By the early 1950s Breer's paintings consistently had an unresolved quality that set them in perpetual motion. The five blocks of colour in *Untitled* (1952, ill. p.14) struggle infinitely with one another to progress to the foreground, with red, white and black seemingly in the lead. In *Untitled* (1953, ill. p. 21) it is the entire canvas that wants to shift, a dark grey plane on the left working with a black window outline to give a biased weighting. The result is a canvas uneasy with itself in either its designated landscape orientation or a portrait orientation – a taste of the self-effacing humour that would resurface in Breer's work. By the mid-1950s transience of a lighter, even balletic, kind had emerged, through forms greatly reduced in scale, punctured by the introduction of free-floating single black lines – a real rule-breaker for plastic convention.

Troubled by the rigidity of painting and its operation within the doctrine of plastic abstraction, Breer refused to submit to 'the notion that everything had to be reduced to a bare minimum, put in its place and kept there'.[3] Mondrian's compositions were forever moving towards a single goal of purity, each painting being a refined version of that which preceded it. Breer, on the other hand, felt that each new canvas reached a new finishing line. 'I could, at least once a week, arrive at a new absolute,' he said.[4] Crucially, this assertion allowed him to see the very process of change, of variation, modification and flux, as an absolute. His abstraction took Mondrian's distilled forms and reversed their journey, releasing them once again into motion and allusion. The process also freed plastic form back into a signifier/signified relationship, the beginning of a play between abstraction and anecdote that would become important later. For Mondrian, and those in his wake, red was red; as Breer would later say, 'red is red and red is blood, and the confusion is both good and right.'[5]

 While Breer's plastic compositions are unified in strategy and sentiment (they have nothing of the fragmentary air of the collagist that would filter into his filmmaking, for example), once on the canvas they battle rather than homogenise. His compositions retain an abstract purity, yet their wrestling and jostling for pole position is a post-Platonic disruption of the drive towards purity at the heart of Mondrian's geometric order. This very tension in Breer's painting is, in itself, a kind of purity. Nevertheless, he was pushing abstraction in a very different direction.

 Despite its many allusions to change, Breer's painting was still what he has since referred to as a kind

of 'fossilized action'.[6] His filmmaking emerged as a necessity; he was, at first, less than enthusiastic at having to deal with the notion of change in real time: 'I sort of backed into cinema since my main concern was with static forms.'[7] Via experiments with flip books, and while continuing to make paintings on canvas, he transposed the abstract forms that populated them onto 3 × 3 inch frosted slides purchased during a trip home to Detroit. The various states of flux alluded to in his paintings were broken down, or rather sequentially built up, until one by one the slides were projected onto a screen and shot frame by frame. This rudimentary form of stop-motion animation physically set Breer's abstractions into motion, thus providing the title of his first animated film, *Form Phases* (1952).

Existing as a painting before it was a film, *Form Phases* was an exercise in '[controlling] a range of variables within a single composition'.[8] It begins with a title credit in a black box that sits within a white border. The title moves to the right, disappearing underneath the border, as another black box slides from the left to take its place. The box, almost a constant in the film, is filled variously by 'cut-out' shapes and heavy white, sometimes coloured, evolving lines that move back and forth between solidity and transience, or as parts of a larger structure. White 'hollows' created within the boxes fill with washes of colour (applied directly to the film), pause, and drain almost as a liquid. The film is slow in pace and without sound. Just as with the windows in Breer's paintings, the boxes establish a tension with the outer frame, sporadically expanding to displace the space between them.

Still evincing a degree of hesitancy, *Form Phases II* (1953) and *Form Phases III* (1954) were trial-and-error experiments in the possibilities of filmic time and space. In *Form Phases II* Breer began to refine pictorial depth. An additional slide with a drawn motif layered above another provides the opening shot. The slide is lifted away, sending the image below to the edge of focus, before it is fully revealed. Line and form congregate and conspire to build plastic compositions held in stasis for many frames at a time before being freed once more into motion and dissolve. The biggest leap is the use of plastic space. Movement is tightly controlled by the limits of a white frame, or a screen-within-a-screen, positioned sometimes to the right, sometimes to the left. The parameters of this box feed and determine the evolution of the shapes within – a circle draws itself, expands to stretch to the picture edge and is then squared. Midway through, the forms fight back: a short black line flashes and lurches sequentially in a frenetic spiral, circling its cage anti-clockwise and then clockwise.

These films picked up where the Dadaist Hans Richter and Viking Eggeling had left off some thirty years before. Richter, also a painter, transferred to film reductively using only black-and-white and, like Breer, allowed the shape of the screen, a flat surface rather than a window to the world, to define space. *Rhythmus 21* (1921), one of the first abstract films, saw line and form grow and recede into an implied third dimension. Going beyond the frame, Richter painted onto scrolls, dragging plastic elements into invisible space. In Eggeling's *Symphonie Diagonale*, also from 1921, complex abstract compositions in black-and-white pulsate and grow along the diagonal

axes of the screen. For Richter, 'rhythm' was the essence of film, the 'conscious articulation of time, of movement'.[9] His films embody a defiance of logical or sequential narrative and denouement. Instead, in that main credo of Dada, he gave 'chance a chance'.[10] Seeing his work soon after completing the first *Form Phases* films legitimised Breer's even more enthusiastic experimentation.

Form Phases IV (1954), made by drawing on paper, was Breer's first fully accomplished film. His experiments with animation up to this point had taught him that a single form moving within an otherwise static space would obliterate everything else.

'You know the usual opening shot of a conventional film, the helicopter shot of a car going down a highway seen from above – you watch that car. It's a tiny dot on a huge screen, but you're glued to that one thing and everything else is peripheral. Once I was making films, I learned that I couldn't work with the stable kinds of relationships I'd worked with in my painting. I had to rethink things completely. And that's when I went for an all-over active screen and for real hectic films.'[11]

Form Phases IV is a *tour de force* of movement and instability. Forms, colours, lines and actions burst, complement and contradict each other across every square inch of screen. An anthropomorphic wit seems to poke fun at the very limitations of this now mastered medium – screens-in-screens appear again, dance, and are obliterated, a drawn film-strip scrolls upwards as random shapes navigate between its cells. Shot in mini-sequences and then edited and re-edited in non-sequential passages,

the film is 'abstract but anecdotal': its forms work both with and against each other. Breer had made movement an absolute, building upon much of the abstraction before him. Mondrian's later *Compositions*, Kasimir Malevich's Suprematism, Bauhaus painting – all are present, their logic systematically subverted.

The incorporation of art-historical precedent makes Breer more or less unique among avant-garde filmmakers, particularly within a European context. Cubism, the root of Mondrian's plasticism, Futurism's obsession with movement and attempts to encapsulate time-lapse in painting and sculpture, and Dada's chance, eclecticism and wit, were all feeders to his animation. After *Form Phases IV,* while continuing to bring a painter's mindset to the task, Breer began to use film in its own right rather than as an analytical tool with which to dissect and expand his work on canvas.[12] Constructed frame by frame and then set into motion, conventional film records and replicates the reality of experience as observed in real time – it is defined by logical, linear, sequential progression, disseminating an otherwise fugitive experience. The conventions of animation are similar, though in this case the images are mediated and constructed by hand prior to the arrival of the camera lens. Breer's most radical step was to bring all of this together and overturn it. While continually alluding to art-historical and filmic conventions, he would work with their limitations, play with them, and break them.

Breer also became increasingly aware of the processes of viewing moving versus still images. An important experience had been a public presentation of *Form Phases IV* alongside his paintings. Reactions were

immediate and plentiful (the animation received high praise at the expense of the paintings, which were largely ignored). This kind of subjective feedback was invaluable to Breer, prompting him to a detailed consideration of modes of perception and their limits. Simultaneously bending the rules of both painting and film, he pushed each closer to the other. The film cell, an individual frame within a strip of film, had a natural affinity with the canvas, as did the 4 × 6 inch index cards Breer was now using to draw each frame upon. By using film he could explicitly control the rhythms of its delivery within the continuous motion of cinema.

'I shot six feet of film … one frame at a time, as usual in animation, but with the following essential difference: each successive picture was as unrelated to the preceding one as it could possibly be. The result was a strip of film consisting of a string of two hundred and forty distinct optical sensations or ten seconds of assault and battery on the retina. To prolong the agony I spliced both ends of the strip together and ran it as an endless loop through the projector.'[13]

Rather than the film proving monotonous, Breer found that with each showing the eye managed to single out new, isolated images, thus becoming responsible, in effect, for the film's overall rhythm. Shown as a continuous loop, giving another dimension to its movement, *Images by Images I* (1954) was short-lived and soon wore itself out on the looper. It was, however, the first of a number of films to probe the tension between the still and the motive, of which *Recreation I* (1956–57) was the culmination.

An orgiastic two-minute assemblage of animation, film footage, real objects and sound, *Recreation I* is a barrage of disparate information. Most of the images are presented so impossibly quickly – for a maximum of one twenty-fourth of a second – that they rarely have time to burn more than the merest flash upon the retina. Owing a debt to the eclectic collage of Kurt Schwitters, the film has a graphic and rhythmic sophistication and spatial division that enhances what Breer found in Léger's 1924 *Le Ballet Mécanique*. Léger's film had been one of the first to assimilate both still and moving images as a rapid, non-sequential montage.[14] Occasionally Breer permits the flicker of another rhythm to enter the equation – a very few frames that repeat themselves, or real-time film footage of an object (a wind-up bird?) meandering across his animator's table. The speed is, otherwise, endless.

Yet it is also paradoxical. Rather than just accentuating the motion of the film and its endlessness, the effect is also to highlight its existence as an accumulation of composite still images – the very nature of film is exposed, the truth of its material revealed. *Recreation I* is pivotal in its discovery and prediction of the defining forces Breer has since developed in his long career: a positioning of his work within a tension between the still and the moving image, and within the interplay between abstraction and representation.

The mode of delivery of *Recreation I* and later ever-more sophisticated films, including *Blazes* (1961) and *66* (1966), is especially revealing. The apparent disorder, random accumulation of imagery, anti-continuity, and lack of single point of focus or resolve together form a set of aesthetic relationships that, in itself, provides structure.

The film is offered as a totality in a manner akin to static images: 'I try to present the total image right away, and the images following are merely other aspects of and equivalent to the first and final image. Thus the whole work is constantly presented from beginning to end and, though in constant transformation, is at all times its total self.'[15]

These films are thus offered within a logic that stems from Breer's painting – 'a still, non-narrative picture even though constantly changing'. A crucial difference between the two media, however, lies in the initiation of change. With painting, it is the viewer who acts as a trigger: the static object alludes to a formal state of flux but it is only the processes of perception and shift in physical relationship to that object by the viewer that bring alteration. With film, Breer took back this control, conducting the variation in pace and interjection of real-time pause to 'define and dramatise what might be otherwise considered to be a relentless continuum'. Stillness is thus defined by its opposition to movement, and vice versa. This power relationship has shifted back and forth in Breer's work ever since, reasserting the significance of change as an absolute and continually reinventing the mode in which it may be perceived.

For a short time during the 1960s, after returning to live in America and permanently abandoning painting, Breer used Mutoscopes. Invented at the end of the 19th century, the Mutoscope is based upon the same principles as the flip book, but is freestanding and attached to a circular core supported at eye-height. A large number of still images are presented together and can be set in motion, continuously or sporadically, by being rotated at a speed determined entirely by the viewer. Breer's

sculpture, which emerged slightly later in the 1960s, found the perfect middle ground: a purity of movement coaxed from an initial apparent stasis.[16] The forms that populated his paintings and then his films were extracted back into the real world, replicated in three dimensions and mounted upon invisible motors and wheels. A kind of deviant Minimalism-meets-Arte Povera-meets-mollusc, shown en masse they allow the viewer to step inside a concrete environment and experience form and change in real time and space. The 'floats', as they would come to be known (or, affectionately, 'creepies' – as should be clear, humour is never far from Breer's art), move at a speed almost imperceptible to the eye, appearing static until they are seen in relation to each other, or to the surrounding architecture. The experience created is that of an environment that continually updates and modifies itself as the forms collide and shift direction. In the last few years Breer has been developing 'panoramas', sculptural, wall-mounted objects made from multi-layered cut-outs in wood – something like film-less films within boxes. Comprising multiple sequences in simultaneous pictorial depths, these panoramas are abstract 'tableaux' that rely completely upon the viewer's motion, walking along their entire length, for their activation.

The rhythmic interruptions of the real within *Recreation I,* temporarily displacing its abstraction, again signalled the beginning of a new development in Breer's work. As his filmmaking progressed into the 1970s, 1980s and 1990s, narrative became more pronounced. After all, 'film is moving, life is moving', Breer has said. In this sense alone *Recreation I* – completed, we should remind ourselves, in 1957 – still seems one of the most

sophisticated summaries and anticipations of the many struggles, and resolutions, between representation and abstraction over the last century. As Hal Foster noted in 1996, 'abstraction did not undo representation; rather, in the moment of high modernism, it repressed or (better) sublated representation, and in this sublation representation was preserved even as it was cancelled'.[17]

In his film work Breer juxtaposes home movies, sometimes 'raw', sometimes Rotoscoped, photographs, sound and footage of real objects physically moving above and between the abstractions of his index cards. *Fuji* (1974), made following a train journey that took him past the mountain in question, jumps from footage of Breer's wife by the train's window to a Rotoscoped sequence of the ticket collector and countless drawn depictions of Mount Fuji, all of which slip back and forth into and out of abstraction. Constructing the collision in a very different way, a gloriously fluid, balletic 'scene' in *Swiss Army Knife with Rats and Pigeons* (1980) (its title alone playing with a clash between disjunctive ordinary things) sees an oblong block of flat red colour tease the formal housing of the outline of a Swiss Army knife. The two 'beings' unite, separate, flirt by criss-crossing above and beneath each other, and finally rest into the 'reality' of being a unified, functional whole. Even within the domain of complete abstraction in painting, film or sculpture, the appearance of anecdote permits a crossing of this boundary; it is curious how quick the imagination is to create anthropomorphic tales that expand upon the 'meeting' of abstract forms. Nevertheless, unadulterated reality or mere anecdote are never used at the expense of the abstraction Breer has always sought. If anything,

and as with his use of stillness to elucidate movement, the incorporation of narrative and representation only serves to send his abstraction to a higher plane.

Breer's greatest achievement, perhaps, has been to use one force to define its opposite – movement to counteract movement, pause to dramatise speed, and representation to concentrate abstraction. Throughout his career he has made many distinguished connections – with the heights of Parisian abstraction in the 1950s, the heroes of experimental cinema, Pop, neo-Dada and EAT in New York in the 1960s, among others.[18] He has had many emulators, with each new generation finding fresh inspiration and vitality in his work. More often than not, he has been ahead of his time; even Marcel Duchamp, upon seeing his films, turned to Breer and said, 'Aren't they a bit too fast?' In its perpetual instability, one clear constant endures in Breer's art: it belongs only to itself, and we are all the richer for it.

1 Unattributed quotations come from conversations with the artist in his studio in Arizona in March 2010 and subsequent email correspondence.

2 Piet Mondrian, 'Les Grands Boulevards', in *Natural Reality and Abstract Reality: An Essay in Trialogue Form*, trans. Martin S. James, New York, 1995, p. 120.

3 Robert Breer interviewed by Robert Gardner, *The Screening Room*, first aired on ABC's Channel 5, Boston, November 1976.

4 ibid.

5 Guy Coté, 'Interview with Robert Breer', *Film Culture 27*, Winter 1962–63, p. 17.

6 Scott MacDonald, 'Robert Breer', *A Critical Cinema 2: Interviews with Independent Film Makers*, Berkeley and Los Angeles, 1992, p. 25.

7 Coté, p. 17.

8 Coté, p. 17.

9 Pip Chodorov, dir., *Free Radicals: A History of Experimental Cinema*, Paris, 2010.

10 Chodorov, *Free Radicals*.

11 MacDonald, p. 20.

12 Yann Beauvais, Interview with Robert Breer, *Scratch Book*, Paris, 1999, n. pag.

13 Robert Breer, 'Images in Motion: A Painter's Notes on Cinema', *The Louisvillian*, November 1957, n. pag.

14 Appropriately, *Le Ballet Mécanique* is as much a development of the formal, rhythmic and spatial strategies of Léger's Cubist paintings as it is an ode to the technological promise of the modern world.

15 Coté, p. 18.

16 Breer's anxiety about the shift to physically propelled objects is revealing: 'The transition to floats was crucial for me and revealed how imbedded some of my notions were, about art. One of my first inhibitions had to do with invisible machinery used to propel these new pieces. IMPURITY! My next dilemma was how to animate these new objects without a kind of pathetic anthropomorphism being suggested! My answer was to limit their behavior and shape to somewhat passive and clumsy, inanimate (inert) objectness – not alive in any animal sense!'

17 Hal Foster, *The Return of the Real*, Boston, MA, 1996, p. 103.

18 Notable examples include collaborations with Claes Oldenburg, Jean Tinguely, Robert Rauschenberg and the pioneering group EAT (Experiments with Art and Technology), especially his important contribution to the Pepsi-Cola-Pavilion at the 1970 Expo World's Fair in Osaka, Japan.

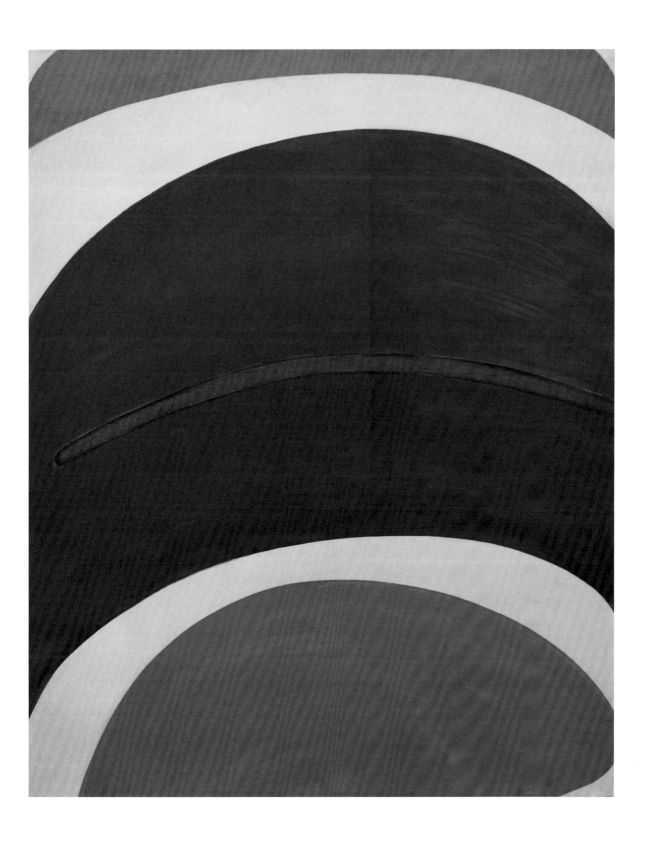

Tournant, 1955
Oil on canvas
99 x 81 cm

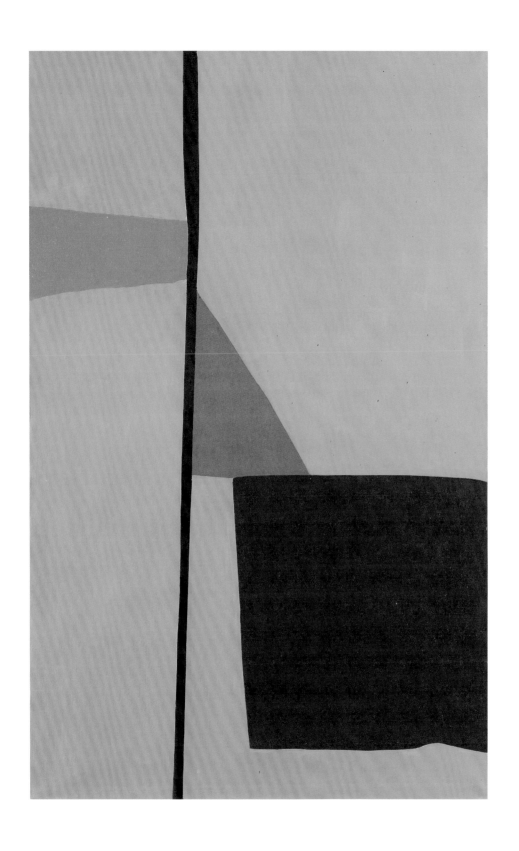

Line Up, 1955
Oil on canvas
116 x 72 cm

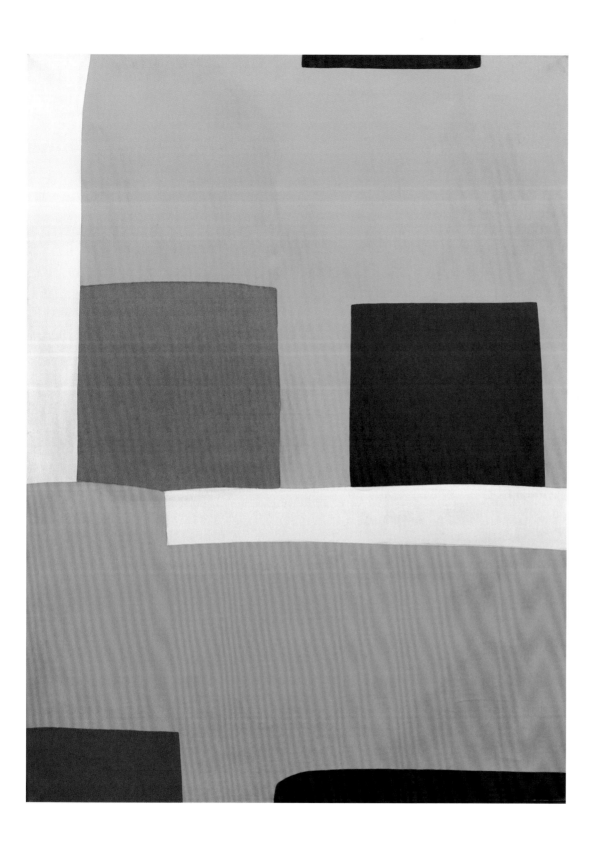

Three Stage Elevator, 1955
Oil on canvas
91 x 60 cm

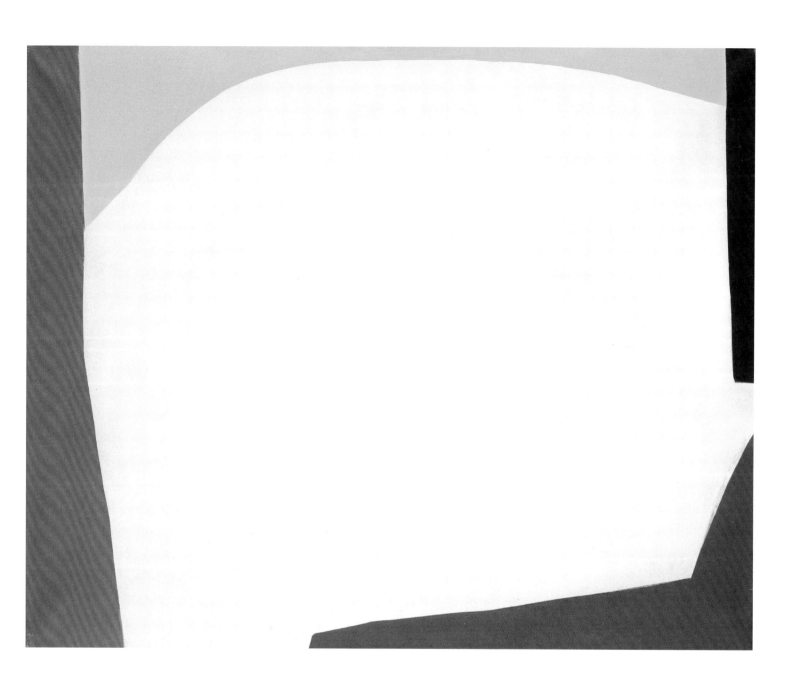

Sky Chief, 1955
Oil on canvas
80.5 x 100 cm

Flip Books

'I realized I was making a lot of absolute statements, paint on canvas, about one a week. I began to ponder how many absolutes there could be, and wondered if the process of getting there might be more interesting than the final resolved composition. I put together a flip book of successive stages in a composition – one shape/color giving rise to the next on their way to a perfect but not final resolution. I wanted to see if that could be of any use to me analytically in showing how I arrived at the final painting. At this time I had become aware of experimental films and I naturally slid into the idea of preserving a flip book on film.'[1]

For the exhibition 'Le Mouvement' in 1955 at the Galerie Denise René, Robert Breer created a flip book titled *Image par Images*. He had started to work with abstract film three years earlier. He now employed the technique of a continuous development of forms that had defined his early films in a different medium. At first glance, a flip book works like a film, in that successive images result in a continuous sequence. The order of images is set; it is usually difficult even to flip through the book in reverse. The development and the (abstract) narrative are therefore given and irreversible. Breer took this on board and, in *Image par Images*, created the first flip book to be shown at an art exhibition.

With his participation in 'Le Mouvement' he joined the ranks of the kinetic artists of that period. The exhibition showed works by Marcel Duchamp, Alexander Calder and Victor Vasarely, and also by artists of Breer's generation such as Jean Tinguely, Jesús Rafael Soto and Yaacov Agam. It was the first extensive exhibition of kinetic art, curated by Pontus Hultén, Victor Vasarely and Roger Bordier for Galerie Denise René.

Breer documented the exhibition in a film that he made in collaboration with Hultén. It was to remain his only documentary, with the possible exception of the film *Homage to Jean Tinguely's 'Homage to New York'*, made in 1960 as a filmic celebration of Jean Tinguely's auto-destructive sculpture.

1 Robert Breer in: Billy Klüver / Julie Martin, 'Robert Breer, A Painter in Paris, 1949-1959', ex. cat., Galerie 1900–2000, Paris 1990, p. 20.

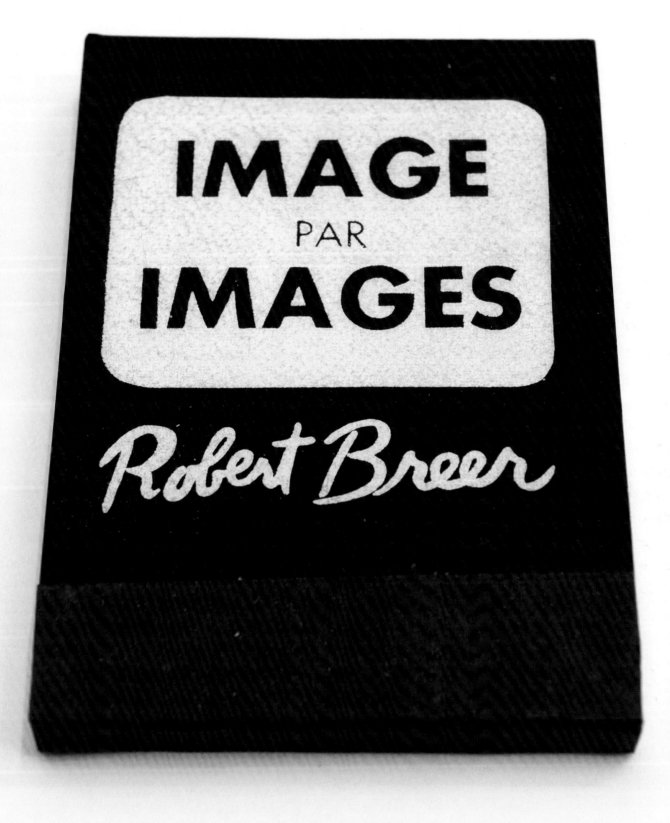

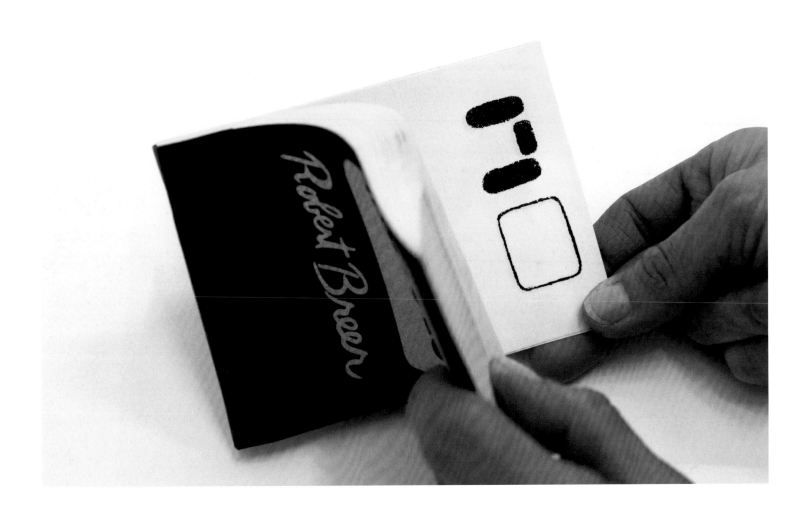

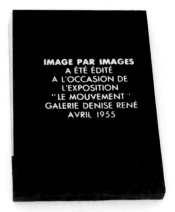

Image par images, flip book, 1955
Cardboard, paper
12.6 x 9.2 x 1.1 cm

right:
Flip book, 1950
Slidecraft, screws
10.1 x 8.2 x 3 cm

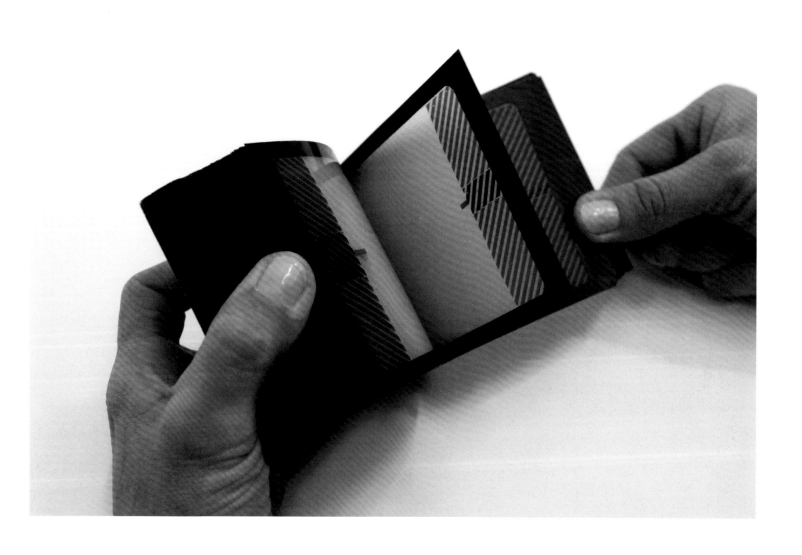

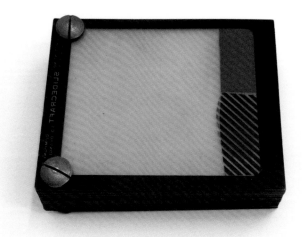

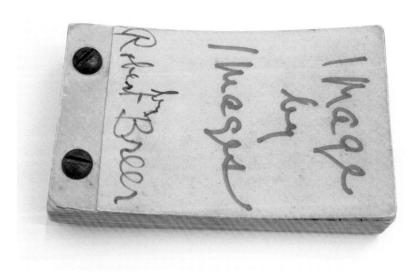

Image by images, flip book, ca. 1960
Cardboard, screws
12.6 x 7.6 x 2 cm

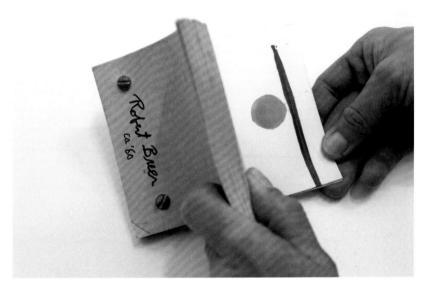

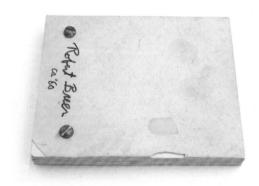

Untitled, flip book, 1960
Cardboard sheets, watercolour, screws
12.7 x 10.2 x 1.5 cm

right:
Flip book, 1961
Paper, screws
5.1 x 6.3 x 1.3 cm

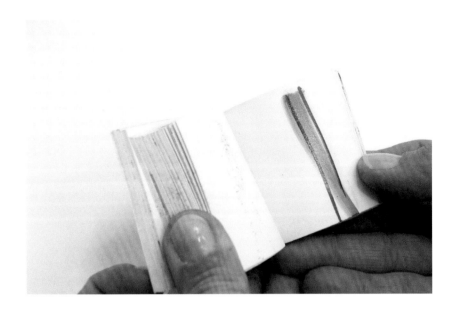

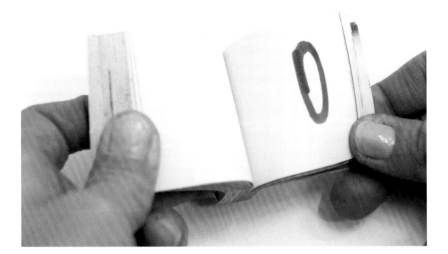

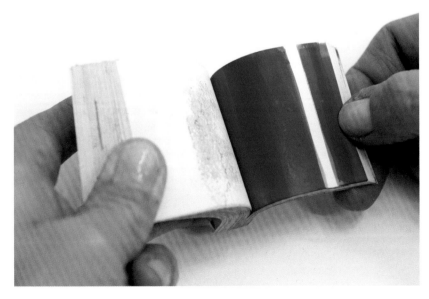

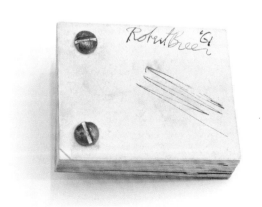

'Fvoom! Just Like That'
24 moments of perception in Robert Breer's films

Ute Holl

'I'd really like to have my films go *Fvoom!* just like that –
one split second [...] But somehow that's not the way
perception works.'

Robert Breer during an interview at the 1966
New York Film Festival

1. 24 images per second

Robert Breer's films perform surgery on cinema's open
heart; they let it pulse 24 times per second, thus pumping a
flow of images into the cycle of visibility: lines and colours,
symbols and material matter. As the human eye cannot
grasp the individual image, it has to keep synthesising.
Figures and shapes, frogs and crows, barking dogs, sleeping
men, photos of leaders and typography. It is impossible to
look at, to observe 24 images per second. One must simply
let the brain run with it, see what happens subliminally
below the threshold of conscious perception, see what is
put together automatically in the optical subconscious as
a result of the images' frequency: more than the sum of
its parts, less than the multitude of the painted details.
Perception works with time and waits to see what it can
do. 24 times per second lines, surfaces, and layers of colour
end up as figures, structures, contours, or images. Figures
appear and disappear. Every time we see a film by Robert
Breer, it looks different. Some images disappear; others are
carved deeply into the memory and stay with us. We never
jump into the same stream of images twice.

2. Bolex

New American Cinema – experiments on 16 mm, standing
apart from the power of the big studios, *independent* –
came about due to cheap material for the home format; and
ever since World War II 16-mm processing laboratories
were built for the home front, for the newsreels. Pioneers
of the American avant-garde, Deren and Hammid, the
'angry young men' of the post-war era, Anger, Brakhage,
Mekas, the stars of the 1960s, Cassavetes and Warhol, all
experimented on 16 mm. And all of them did so with the
Bolex-Paillard, the 16-mm precision instrument from
Yverdon, a Swiss clockwork of a camera, setting the pace
of the avant-gardes: three fixed lenses, continuously
adjustable speed, and a spring drive with a winding
handle. As independent as possible. From the start of his
career in 1952, Robert Breer also worked with his father's
Bolex, which allowed precise stop-motion montages. Exact
to one hundredth of a second, image by image, exposed at
home on a DIY animation stand. Assembled and projected
image by image, sometimes shown simply among friends,
sometimes in galleries or at festivals. Breer's *Fist Fight*
(1964) was shown at the 1966 New York Film Festival. He
is shown in conversation with Jean-Luc Godard, who had
shown his *Le Petit Soldat* (1963) at the previous year's
festival.[1] Photography is truth, says the photographer in
Godard's film; and cinema is truth 24 times per second.
Breer reverses this statement: '*somehow that's not the way
perception works*.' An individual image does not contain
a cinematic expression. A single frame does not provoke
movement. Film is perception in relation to the frequency
of images. It deceives the eye and disappoints expectation.

3. Eyewash

Robert Breer's films are eye-cleansing devices; they
wipe the sleep from the eyes, pull away the veil of
usefulness, let us see for the sake of seeing, let us watch

without aim or purpose, perceive whatever may reveal itself from the corners of our eyes, inattentive, so that the unplanned sneaks into our vision. *Eyewash* (1958–59) starts with blurred pictures, lets them swoosh past, washes our vision with mixed images. In Breer's films we see ourselves seeing.

4. On a whim

The point of Breer's films is to confuse our usual way of looking at things. They're 'whimsical', as the critics like to say.

5. Pre-cinema cinema

Robert Breer's films are personal and subjective, increasingly close to the bone, always dealing with the private and even, in the case of *What Goes Up* (2003), with private parts. At the same time they are cool products from the laboratory, experiments with old devices, optical toys from the 19th century, magic drums, image sequences viewed through slots on a rotunda, zoetropes, vitascopes that let us experience how the brain processes what the eye sees. Or the simple thaumatrope, a twirling piece of cardboard, fusing two individual images on either side of it into a single one, as used by Breer in *Bang!* (1986) to water a flowerbed through a waterfall. Or the mutoscope, a flip book mechanised with a crank handle, a mini daylight cinema giving the illusion of motion to static images. Breer built such devices in the 1950s and 1960s to run his painted pictures in series, faster or slower depending on how the viewer felt, and independent of a projector. *Independent.* Infinite loops: we can see as many images as we want, as quickly as we can.

6. Repetition

Every time we see a film by Robert Breer, it looks different. Some images disappear; others are carved deeply into the memory and stay with us. We never jump into the same stream of images twice: 'the next time you see the same thing your experience of it is different because it's the second time you've seen it,' states Breer in an interview with Yann Beauvais.[2] Repetitions bring images back and change them at the same time. They short-circuit time. This can be annoying, as in the soundtrack of *LMNO* (1978), a piano. Looped? Practised? In the film *Fuji* (1974) the drawn image of a tumbler rolls around the screen again and again, seen from ever-changing perspectives, knocked over on a train journey by the judder of the tracks that transfers into the drawing. Into the image. Images fly by like landscapes past a train window. The film only lets the images rest after it has repeated the same thing often enough, 24 times per second. Stills are repetitions in the viewer's eye. Not yet the truth.

7. Flip book

In the beginning there was the flip book, the folioscope, created by Robert Breer out of curiosity: an experiment for hungry artists, an experimental setting – then, all of a sudden, art. In the 1950s in Paris. Dots, lines, series, squares flipped into motion. *Un cinéma de poche.* 98 sheets, 98 black and white images, portrait format, bound at the bottom. Sheets of 9.3 x 12.8 cm. Breer's flip book was the first to be considered art in the art world; it took its place in a gallery, in Denise René's exhibition *Le Mouvement* in April 1955, based around Europe's kinetic avant-garde, from Vasarély to Tinguely, Breer's European anchormen.[3]

The title of his flip book was *Image par Images*. Image by image. Sheet by sheet, metonymic viewing, 98 times, that could be converted into cinematic terms: 4 seconds of *cinéma de vrai, cinéma de vérité*. *Image par Images* was mechanised by Breer with his father's Bolex in Detroit. 3 x 4 inch Breer pictures in sequence. *Image by Images I* (1954), first film, first loop, *film en boucle*. Later Breer painted onto 4 x 6 inch paper cards that he projected and then photographed with his camera. 24 images, 24 frames. Mechanisation plus time equals transformation: dot turns into line, line turns into perspective. Motion, animation, creating dimension. Projection defines space and time. In the 1960s everybody in New York made flip books: George Brecht and Jack Smith, Stan VanderBeek and Andy Warhol.[4] And once again, encore, Robert Breer, with *Flix* (1967).

8. From scratch to flicker

From line to light. A cross, a line, a stickman moves through the picture, draws his lines in the sand, suddenly has a dog and is drawn along by it – or do we just think that? *A Man and his Dog out for Air* (1957) is a film of lines, *méthode graphique*, scratched, from scratch, onto paper, animation in its purest form, halfway between the figurative and the abstract. Spatial illusion. The line turning into a man and his dog out to draw breath, take in fresh air, was the supporting film to Alain Resnais' *L'année dernière à Marienbad* in New York's Carnegie Cinema. Animated movie and zeitgeist. Repetition. This was not a first for Breer. He did not start with a line, but a black square, spinning, with channels running through it, filling up with colour, falling apart. *Form Phrases* (1952)

is a study of figure, perspective and movement, following studies by early experimental filmmakers Hans Richter, Viktor Eggeling and Walter Ruttmann. Like them, Breer looks for force fields in light and motion; he comes to filmmaking as a painter: 'As a painter I was working out of Bauhaus traditions. [...] It is true that my films had their roots in European experimentation of the Twenties.'[5] *Form Phases I–III* are patterns and observations of early avant-gardes. *Form Phases IV* is the first to arrive in the 1950s; it uses flickering, effects in the pure light and logic of the frequencies, and light oscillations, beyond form and figure. Rapid alternation of brightness and darkness results in flickering in other films by Breer, too. *69* (1968) starts off with a hard flicker. And *Fist Fight* (1964) is already playing with frequencies, to the sound of a concert by Karlheinz Stockhausen who also plays with frequencies. Images and tone colours. Oscillographies. *Eyewash* flickers, the effect amplified by playing with different colours. The spectrum of cinematic motion effects is endless, from the dot on a surface to the oscillation in the room.

9. Stroboscopy

Persistence is to vision as animation is to the gaze. Motion in cinema is stroboscopic, activity of perception, synthesis of superimposing frequencies, creating motion where there is really only a sequence of individual static images. From 16 stimuli per second onwards, the eye starts to flicker, switches perception, tunes in and moves into the world of rapid image sequences. From small differences perception creates the illusion of movement. Breer connects images that have no connection with each other: 'Breer's invention was to abolish all of the slight variations and to project a

continuously repeating strip of film in which each frame was essentially independent of the others.'[6] He turned independent images into *independent* movies. From the centre of this crazy stream of images, as film historian P. Adams Sitney writes, a new static structure appears, 'an affirmation of the static in the center of the greatest speed that cinema affords.'[7] An image from the eye of the storm of images. The afterimage effect, the inertia of the retina, retains areas of lights and colours. Stroboscopy extracts movement from intermittent light. In his montages Breer systematically juxtaposes stroboscopy against the persistence of the afterimage effect. In this way we see fast and very slowly at the same time in his films.

10. Avant-gardist and extra-vagantist

Robert Breer is a hybrid; his films are interfaces between avant-gardes, European and American. From the corners of our eyes we can detect both in his films. And leaps in time, from the 1920s to the 1960s. Breer, the *missing link* or break: 'A [...] European aspect of my work might be that it is more conventionalized than that of the Americans, [...] I like this idea of limitations which you break all the time.'[8] A gentleman from Detroit breaks with European conventions, with continental paradigms. Even with his favourite filmmakers, such as Jean Vigo, the poet among the documentarists who turns water into light in a film about an Olympic swimmer. Refraction, the breaking of light-rays. *Excuse me while I break the rules*. In America he comes across the New American Cinema, Anger, Brakhage, Kubelka, Baillie. Breer does not join any groups; he does not join in. He films for a fellow artist only once: *Homage à Tinguely's 'Homage to New York'* (1960).

Switzerland/USA mirror image. Breer observes the avant-gardes while crossing their borders, their light walls and sonic barriers. *Bang!* (1986).

11. Rotoscoping

An out-of-focus close-up, much too close, of a face, glasses and nose, in front of a train window; behind it Mount Fuji flies past. The face is converted into lines; it vanishes into the lines, into the drawn contours. While the movement continues, the substance of the image changes, the Japanese face vanishes into the glistening screen. In his film *Fuji* (1974) Breer uses a new process and a new device, rotoscoping, to transfer films into drawings, image by image projected onto a sheet, a drawn abstraction of photo reality. Real images are traced into sketches for animation. Contours are emphasised, images become impressions, recordings become inscriptions. The rotoscope was invented in 1917 to transfer filmed life into lines, for the animation industry. But Breer does not subject the lines to economy or simplification. The painted tracking shot through a park in *Swiss Army Knife with Rats and Pigeons* (1980) is intricate and astonishing. In *Fuji* and, who knows, on Fuji stock, he sketches a train ride along the volcano. He follows the outlines of the pictures of the journey with a few brushstrokes. Mount Fuji remains a triangle that moves, yet still remains unique and in its place. Breer sketches the world into motion, sets perspectives in ink, rhythmises ink-rendered elements, places formalised moments from rotoscoped material next to each other. Superimposition of the filmimages becomes simultaneity in rotoscoping. So the rotoscoped sequences are flowing and fractured at the same time. Roofs of houses moving

past look like Japanese characters. The characters again remind us of the photographed images in the film. These also reoccur and remind us that those inscriptions used to be film, and that film used to be writing: Cinematography. In the rotoscoped material we watch ourselves wondering about images and signs. From a train window in Japan.

12. The time cinema takes

Tempus fugit, time takes a flight, *Time Flies* (1997), flying watches, whizzing minute hands, an old man who snores and loses his time. Can't be Breer! 'The way to deal with time is to take your time. And for me, the time duration was seemingly endless, and therefore static in a sense, well, you see, it's consecutive, but all on the same level.'[9] The fragmented time of cinema becomes duration and moves on the planes of a Möbius strip on which the times keep returning. Family photographs of old holiday sites, drawings that reduce them, refer to them, separate themselves from the photographs, yet return on the film strip. Every time we see a film by Robert Breer, it looks different. Some images disappear; others are carved deeply into the memory and stay with us. We never jump into the same stream of images twice. The brain produces its own space and time in cinema, says Breer. 'You make it linear by your consciousness, it might be linear in physical time but it's also that you set up action and response and that this is constantly going on in your brain,'[10] he stated in 1983, in Paris, in an interview with Yann Beauvais who translated this into French and condensed it slightly: 'Tous cela devient linéaire par le truchement de notre conscience.' Actually, it should not be 'truchement' but 'travaille de notre conscience'. The work of perception.

In 1963 in New York Breer had remarked, 'I think of film as a "space image", which is presented for a certain length of time. [...] In film, the period of looking is determined by the artist and imposed on the spectator, his captive audience.'[11] Time does not pass, it runs, flies. In the film *Time Flies* (1997), a girl watches a naked woman sleeping. Her mother? Herself in reverse, shot after time has flown by? Time and age meet in the film, by far exceeding any diegesis or biography; they become passages of life itself, circular as are all rites: 'It's consecutive, but all on the same level.'[12] Time flies, but it will not get lost in film.

13. Collage

Another step takes us right into the heart of the substance and transubstantiation, the miracle of 1954: *Un Miracle* (1954). No longer forms, but stuff, collage, stuck-on things animate images and with blasphemy: the film, mounted with the help of Pontus Hulton, shows Pope Pius XII as he presents himself at the window and entertains the audience with tricks: a juggling pope whose head gets mixed up with the balls. In the reverse shot are the people, *populus romanus*, plebeians and well-to-do who are happy and wave their paper arms. After the miracle a creation from material, *Recreation I* (1956–57), cubist stuff that frees itself of paper, stuck-on things becoming unstuck, measuring tape and penknife, film reels and mice, photographs, inscriptions and cut-out animation, things that catch the eye, and a wound-up tin chicken that leaves traces where it walks with its inky claws. In collaging, in photo montages per second, Breer becomes possessed by the spirit of Dada, mixes typography and newspaper pages, draws lines from threads, becomes anti-

authoritarian: as such, Hitler, Napoleon and the militarist are the material that collages shape into clowns: *Jameston Baloos* (1957). Breer's material collages from the 1950s disconnect and connect the senses, very arbitrarily and very fast, stretching and over-stretching them. 'Breer makes "collage" films in which vast numbers of disparate images are rushed, rapid-fire, past the viewer, causing a sort of visual orgasm.'[13] Sheldon Renan read this same term in Breer's work: 'One doesn't actually see any one picture, but has the impression of thousands. It's a form of visual orgasm.'[14] Breer connects the 'orgasm' to seeing the disparate. We cannot read up on this. We can only do it.

14. In between movement

In Breer's films all sorts of movements take place at the same time: camera, object and material movements such as flowing ink or paper that gets un-scrunched, animated motion, the motion of the film track, stroboscopic, hallucinated movements, moirés, colour oscillations, etc. There is not a single fixed point of view in the films. Maybe this is the reason for all those pilots and divers everywhere.

15. Remembering/forgetting

The loose connections between Breer's images do not lend themselves to coherent storylines. Never-ending transformations do not allow for a linear time-structure, no forwards and backwards, no anticipating of what may lie ahead: 'The result is that the "collage films" such as *Image by Images I* and the "line films", such as *Par Avion* and the various hybrids in between all defy either anticipation or memory.'[15] Memory is challenged and encouraged, supposed to find new anchorage. In

this way, cinema functions like dreamwork. It does not organise its affinities chronologically but according to similarities. Like a picture puzzle. The film remembers, unlike us. Cinema lays the traces, we linearise them: 'this is constantly going on in your brain.'[16] Cinema is more powerful than chronology and reorganises the images in the long run. Memory in Breer's films is created as an impression under time pressure. 24 times per second. A black crow flutters about between the images and, where it appears, marks the time. 'Goodbye, Robert,' somebody shouts in the soundtrack, and a young girl in the street, on a photograph, looks into the sun's evening light, her hand raised in a wave. Every time we see a film by Robert Breer, it looks different. Some images disappear; others are carved deeply into the memory and stay with us. In the recursion of the films we watch ourselves remembering. This is the reason for Breer's affinity to Resnais, because their images bear no resemblance at all.

16. Black screen

In between images there are long periods of black screen. Black frames. Black squares. Frames that define cinema space beyond the scope of the film. Seeing is projected onto itself.

17. Rhythm, sounds

Breathing (1963), gasping for air, panting, miaowing, barking and the wind in the trees are sounds on which Breer builds his films: channels to the world in the acoustic. But he also mounts mechanical rhythms, for example the rattling of the train and the buzz of the camera in *Fuji;* or he gets Noel Burch to rattle through

the text in *Recreation* in a machine-like staccato. Typewriter-like. Breer's work with sound spectrums oscillates between Murray Schafer's soundscaping practices and Pierre Schaeffer's *Musique Concrète* that isolates sound elements from tape recordings and remounts them without regard for their origins. Breer also collaborated with Schaeffer's antagonist, Karlheinz Stockhausen, whose composition *Originale* was played to the screening of *Fist Fight* in New York. In *Bang!*, finally, Breer makes fun of his own hardness of hearing and alternates noise – helicopters, jet fighters, gunshots – with silence. Typography becomes the scream for the deaf man; the eyes do the job of ears. Job-sharing of the senses. According to Breer, sound has always been secondary to him: 'What I wanted to emphasize was the visual structure. And sound had a way of taking over. So I always put my sound on afterwards.'[17] However, the soundtrack often starts before the pictures do: inversions of the senses' work.

18. Beautiful red colour

In the tradition of Bauhaus and the Abstraction/Création group, of Kandinsky, Mondrian and Klee, Alpers and Rauschenberg with whom he becomes acquainted in New York, Breer experiments with colours as materials and force fields, and translates this from painting to film. He mixes watercolours, chalk, pens; he glues coloured cellophane onto slide glass, projects and refracts light, and breaks the rules of the brush. 'I could see that green and red did not make grey as it does on a palette but makes a kind of yellow. It's common knowledge now that mixing projected light is different from mixing pigment, so I wanted to speculate on what would happen if I changed

form radically in the same way...'[18] Light and colours have already been used in *Form Phases* to disrupt and transform figure and pattern. And to disrupt the conventional organisation of emotions in film colours: 'You can mix up symbols and convention: a red can be a red, or it can be blood, or it can be confused.'[19] In film red can flow. In painting it cannot.

19. Elementary structures: family

Breer borrowed his first camera from his father, an engineer and 3D film amateur. Later on he used photographs and film recordings of his children, the family, family holidays, the houses the family lived in, the cat on the veranda. Is there a better family picture than that of the family's lawn-sprinkler, endlessly moving back and forth? Later films are dedicated to his children. It was boring but unavoidable to use the family in his work, says Breer: 'a ready source for material, that was familiar to me and real and yet could be kept second in importance to the formal construction...'[20] The forms of the family expand in the montage's seriality. '*Fist Fight*, unlike any other of Breer's films, is autobiographical. In it he contemplates and manipulates still images from his past in what is apparently a moving family album. Black-and-white photographs of his wife as a girl, of himself at his work table, of children, a wedding party, and many friends and personal scenes are scrambled together with fragments of cartoons [...] The personal material blends into the animations and fragments without assuming a privileged emphasis.'[21] The montage of snapshots crosses out the elementary structures of kinship. Children, looking innocently into the camera, are, after the editing

process, confronted with things they should never have seen. Different generations meet, but all at the age of twelve. Relations in film are not stable. Others are mixed into the images and become family, *familiar:* crows and beetles, The Beatles, fighter jets, drawn by the father's hand.

20. Frog film haiku

The filmed pond. A drawn frog leaps in. Plop. Breer's cinema produces haikus. By the minute. Mixes impressions taken from reality, forces realities on us that come leaping across artistic techniques. *A Frog on the Swing* (1988). A tracking shot across water-lily leaves, at exactly the right speed for turning them into the tableau on the screen: the frog greets Monet. In the meantime the montage disrupts the calm: aeroplanes and helicopters in the sky, whistling bullets, yelling children. The frog greets Marinetti. A drawn hare is shot dead. Plop. Greetings to Dürer. A frog leaps; the garden swing swings into the void.

21. Measures against Plato's cave

Breer is not a big follower of old cinema as a tunnel of perception, with the audience tied up in a cave with projection from the back: 'a captive audience nailed down to their seats in a black room'. Therefore he prefers to plan his work for galleries, museums and mutoscopes, even for television or the video rental shop – but maybe he does not plan for others at all. 'I don't make films with any particular audience in mind. I don't know whether I make them for myself: I make them by myself, and that's closer than for myself.'[22] Breer's cinema is determined by the expansion of possibilities to see, not by understanding. Look over your shoulder. Observe from the corner of your eye. Fish an image from the flood or the frog pond.

22. Silence

When the sound stops, always abruptly, audience members hold their breath. Only after a while does the visible take over the frame. 'I do have long periods of silence, helpful silence where the image has to take over.'[23] Breer's cinema jumps between ear and eye to keep perception open.

23. Cinema and painting

Right into the boom of the serial, into the 1950s age of abstractions and of the operational, Breer mounts the unique, painted by hand, brushstrokes, self-glued, art objects, serial singularities, and shoves the auratic work into mechanical reproduction. Film projection interrupts the age of painting. Perceived as painting, film becomes a crystal image, '*Fvoom!* just like that,'[24] as in the wish expressed by Breer during an interview. 'A painting can be "taken in" immediately, that is, it is present in its total self all times. My approach to film is that of a painter, that is, I try to present the total image right away, and the images following are merely other aspects of and equivalent to the first and final image. Thus the whole work is constantly presented from beginning to end and, though in constant transformation, is at all times its total self.'[25] For André Bazin the difference between painting and cinema lay mainly in the framing that, in painting, directs attention towards the centre but in cinema directs it towards something beyond the frame: 'everything that the screen shows us is designed to spread infinitely into the universe.

The frame is centripetal, the screen centrifugal.'[26] Annette
Michelson adapts this thesis to unearth the moment of
a subversive operation in Breer's films; Breer was not
interested in telling a story, but in opening up direct access
to the object. 'In America, the work of Robert Breer, for
example, has an immediacy produced by the elimination of
narrative, as plot, or plot reconceived as progress, involving
a complex visual logic, high speed of images, the use of
subliminal vision. All these factors articulate a cinematic
aspiration toward the condition of the "object" instantly
apprehended, an aspiration shared by our most advanced
painting today.'[27] Films like those of Robert Breer allow
us to see things and their transmission at the same time.
And feel it.

24. Breer's key on the chain that creates time

Robert Breer's films no longer simply raise the question
of what a filmic image might be, but rather what it does:
what it does to perception, and what perception does to
images. The time, for example, that links the individual
elements with its duration: 'time duration was seemingly
endless, and therefore static in a sense, well, you see, it's
consecutive, but all on the same level. I think this is a key,
and I've made steps in this direction. But I think most of
our films are tendencies. I'd really like to have my films go
Fvoom! just like that – one split second. You wouldn't have
to pay; you'd come in and go out. But somehow that's not
the way perception works.'[28] To be perceived film images
must be ironed out, 24 per second. In random order. The
cards can be shuffled arbitrarily. Perception sorts images
in hindsight, for the duration, opens up meaning and new
directions. That's the way perception works.

1 For transcripts of the discussions see: *Film Culture. America's Independent Motion Picture Magazine. The N.Y. Film Festival Issue*. No. 42, Fall 1966, p. 13 ff.

2 *Films, Floats & Panoramas*. Robert Breer. Éditions de l`oeil, St. Étienne, 2006, p. 166.

3 Christoph Benjamin Schulz, 'Il faut tourner la page', in: *Kunsthalle Düsseldorf, Daumen Kino / The Flip Book Show,* ex. cat. Düsseldorf, 2005, pp. 70–85, here p. 72.

4 See Schulz, 'Il faut tourner la page', as above, p. 117.

5 Unpublished interview with Robert Breer, as quoted by P. Adams Sitney, *Visionary Film. The American Avant-Garde 1943–1978.* Oxford, New York, Toronto, Melbourne, p. 28.

6 P. Adams Sitney, *Visionary Film,* as above, p. 279.

7 P. Adams Sitney, *Visionary Film,* as above, p. 279.

8 Unpublished interview quoted from P. Adam Sitney, *Visionary Film,* as above, p. 282.

9 Robert Breer on His Work, in: *Film Culture,* No. 42, as above, pp. 112–113, here p. 113.

10 Une interview de Robert Breer. Notes et traduction de Yann Beauvais. New York, 15 novembre 1983, in: *Films, Floats & Panoramas,* pp. 125–139, here p. 135.

11 Guy L. Coté, Interview with Robert Breer, in: *Film Culture,* No. 27, Winter 1962/63, pp. 17–20, here p. 17.

12 Robert Breer on His Work, in: *Film Culture,* No. 42, as above, p. 113.

13 Sheldon Renan, *An Introduction to the American Underground Film.* New York, 1967, p. 129.

14 Guy L. Coté, Interview with Robert Breer, in: *Film Culture,* No. 27, p. 20.

15 Sheldon Renan, *An Introduction to the American Underground Film,* as above, p. 129.

16 Une interview de Robert Breer. Notes et traduction de Yann Beauvais, as above, p. 166.

17 Charles Levine, Interview with Robert Breer, *Film Culture,* No. 56–57, 1973, pp. 55–68, here p. 61.

18 Une interview de Robert Breer. Note et traduction de Yann Beauvais, as above, p. 158.

19 Guy L. Coté, Interview with Robert Breer, in: *Film Culture,* No. 27, 1962/63, pp. 17–20, here p. 17.

20 Une interview de Robert Breer. Notes et traduction de Yann Beauvais, as above, pp. 157–169, here p. 168.

21 P. Adams Sitney, *Visionary Film,* as above, pp. 278–279.

22 Robert Breer on His Work, in: *Film Culture,* No. 42, as above, p. 113.

23 Charles Levine, Interview with Robert Breer, in: *Film Culture,* No. 56–57, 1973, p. 62.

24 Robert Breer on His Work, in: *Film Culture,* No. 42, as above, p. 113.

25 Guy L. Coté, Interview with Robert Breer, *Film Culture,* No. 27 as above, p. 17.

26 André Bazin, 'Malerei und Film', in: *André Bazin, Was ist Film?* Berlin 2004, pp. 224–230, here p. 225.

27 Annette Michelson, 'Film and the Radical Aspiration', in: *Film Culture,* No. 42, pp. 34–42, here p. 42.

28 Robert Breer on His Work, in: *Film Culture,* No. 42, as above, p. 113.

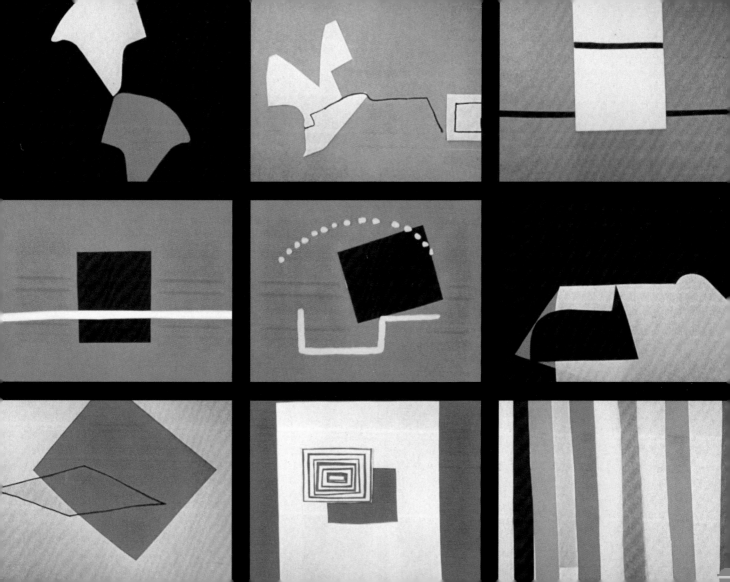

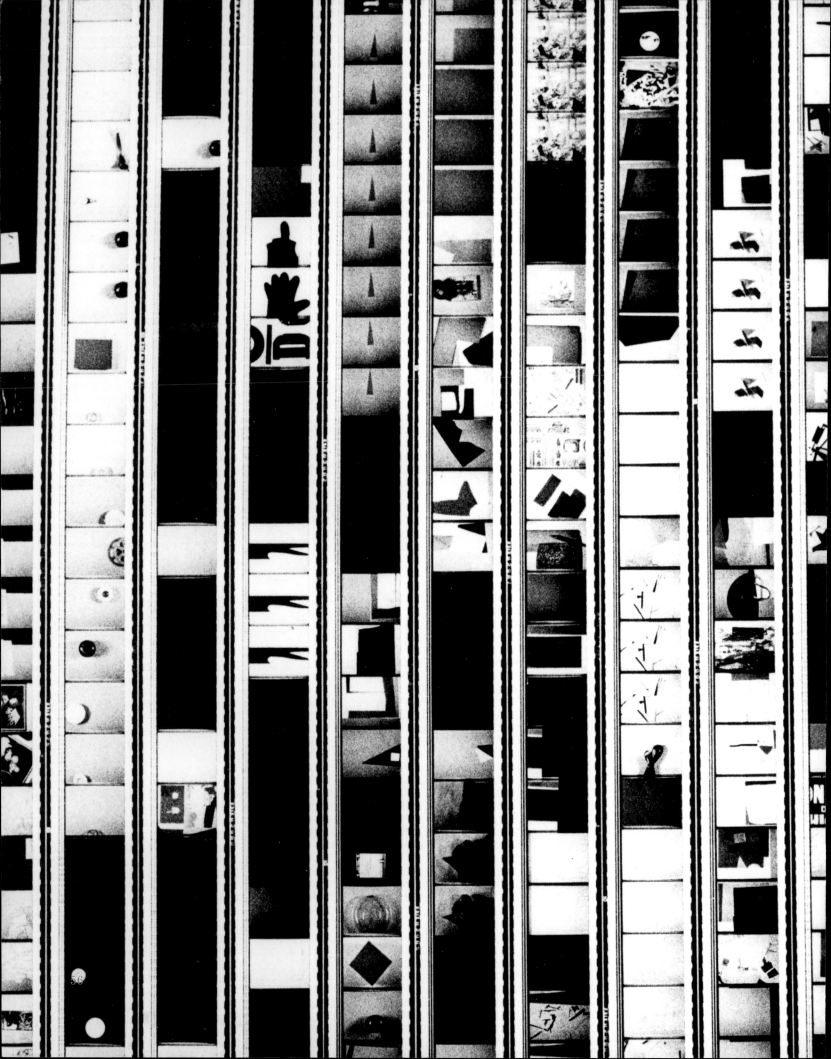

56

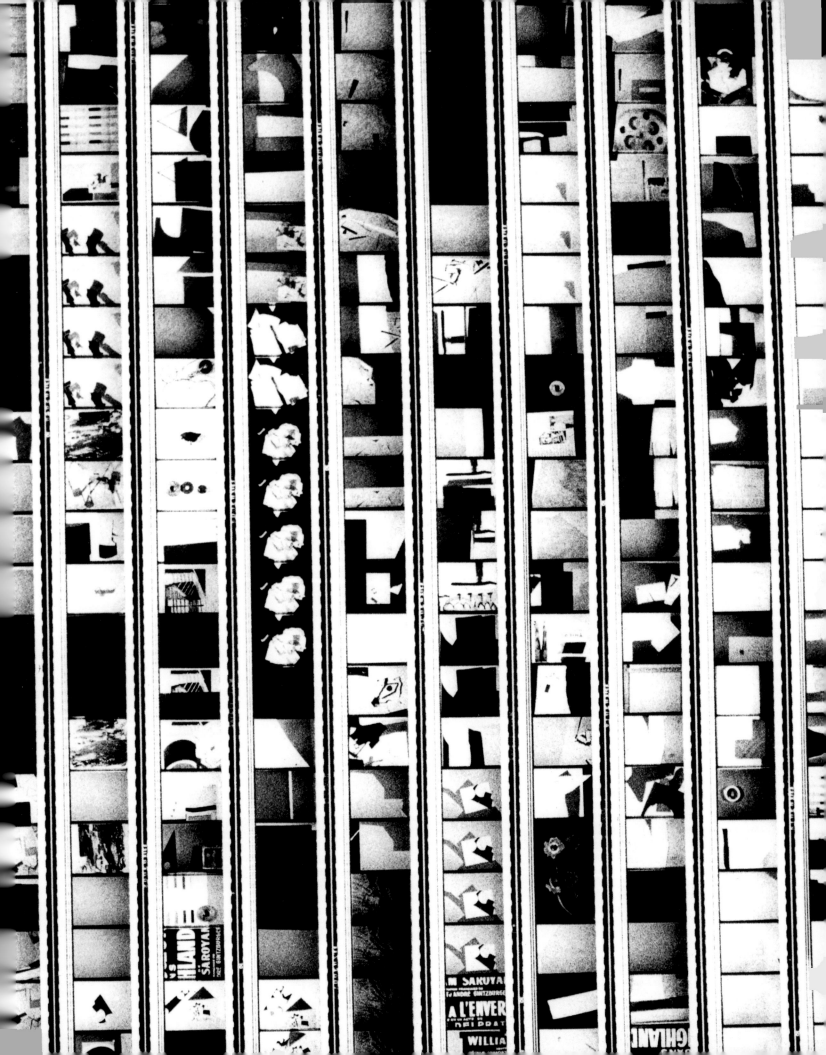

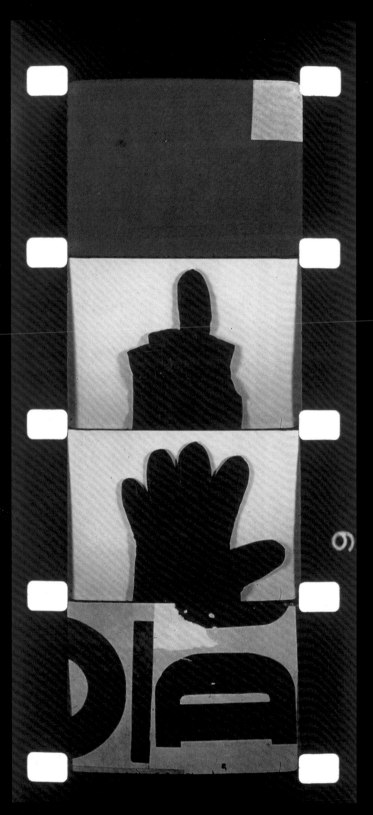

Untitled, 1956–1957
Photogram from the film *Recreation I*

Pages 56/57:
Recreation, 1977 (film realised in 1957)
35 mm film, Kodachrome, framed under Plexiglas
76.2 x 190.5 cm

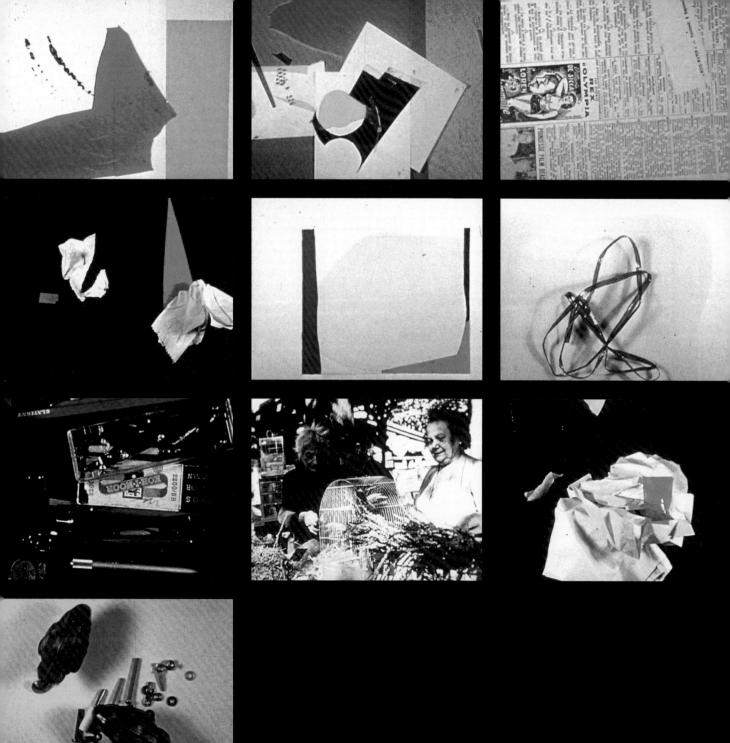

Stills from the film *Recreation I*, 1956–1957

Untitled, 1957
Photogram from the film *Jamestown Baloos*

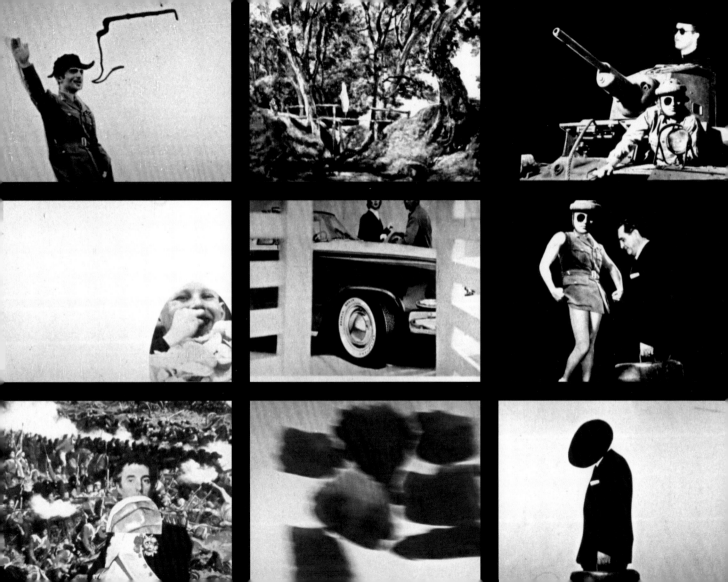

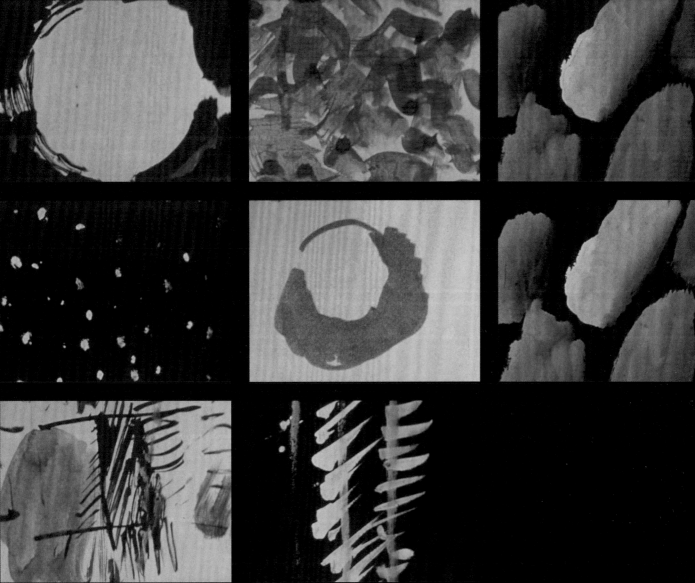

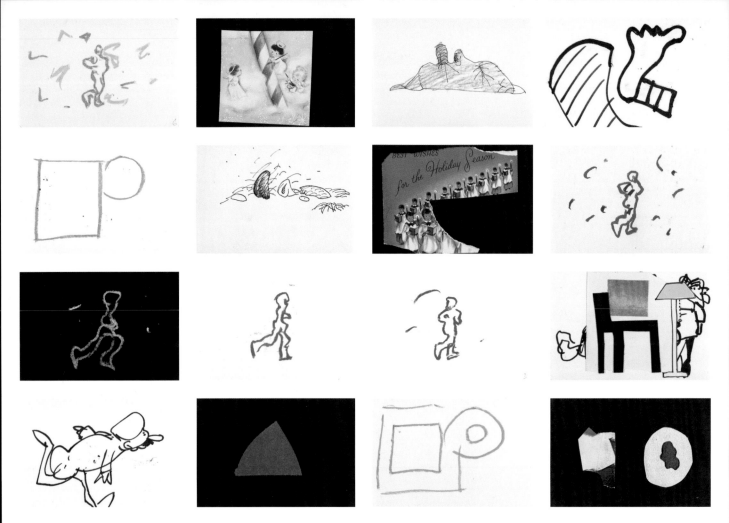

Drawings for the film *Fist Fight*, 1964

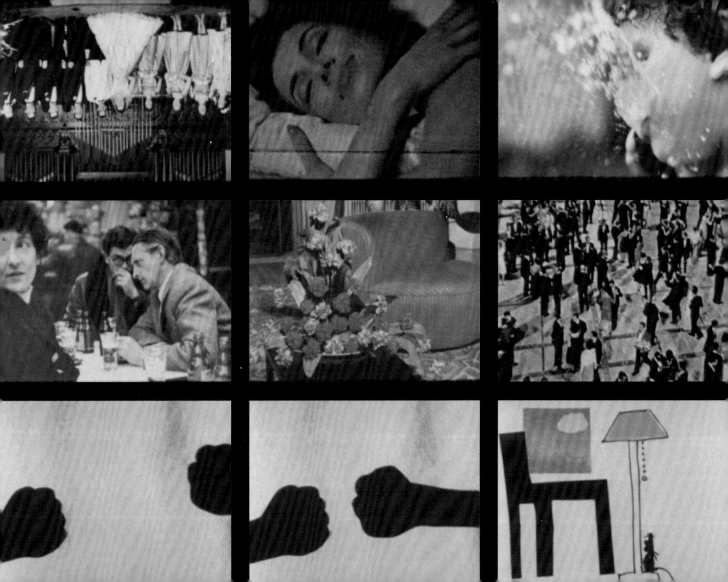

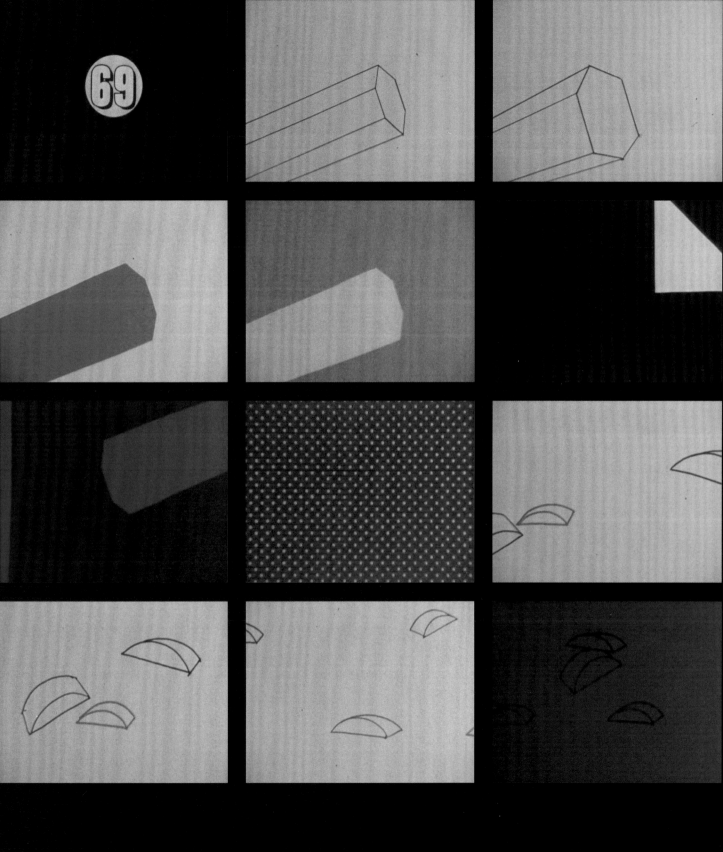

Stills from the film *69*, 1968

Untitled, 1974
Drawings for the film

right:
Drawings for the film

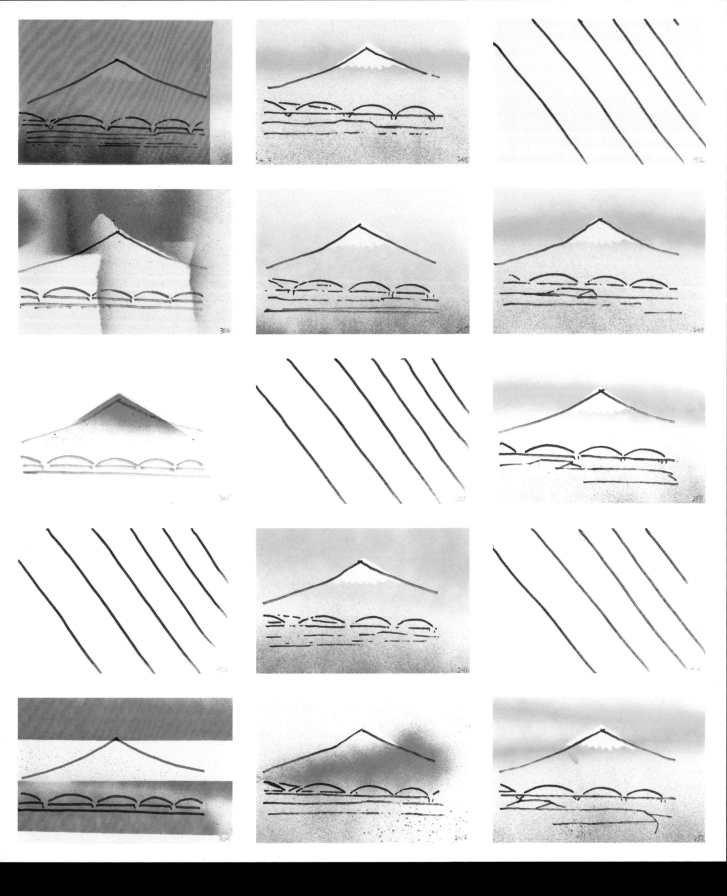

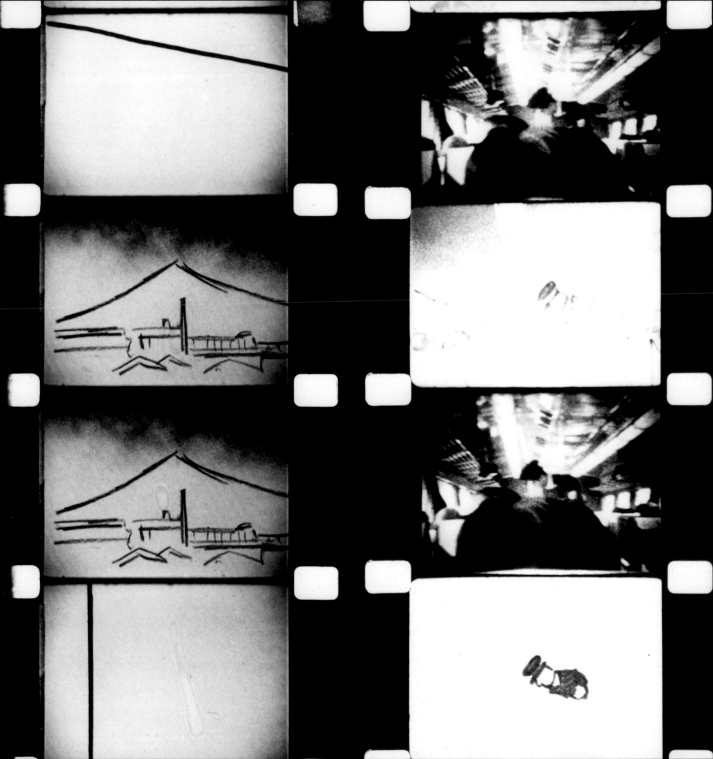

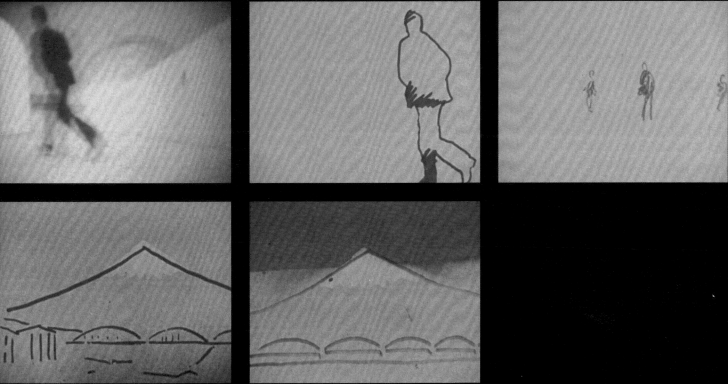

Drawings for the film *Swiss Army Knife with Rats and Pigeons*, 1980

Drawings for the film *Swiss Army Knife with Rats and Pigeons*, 1980

Untitled, 1980
Photogram from the film *Swiss Army Knife with Rats*

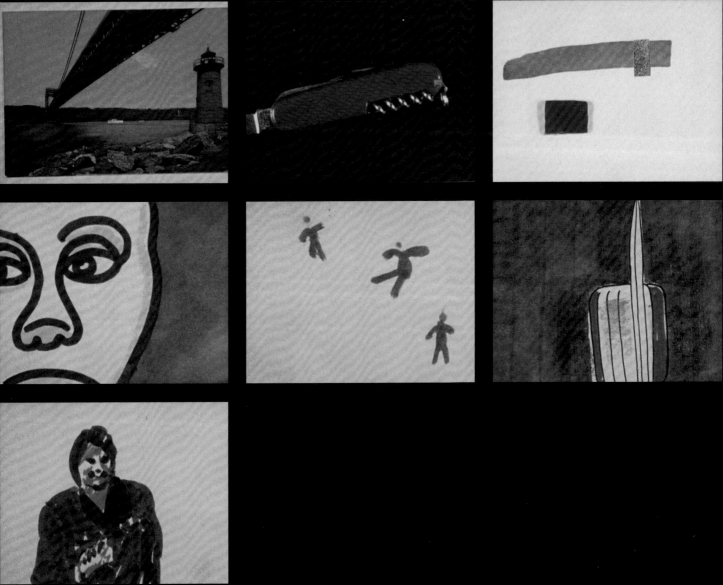

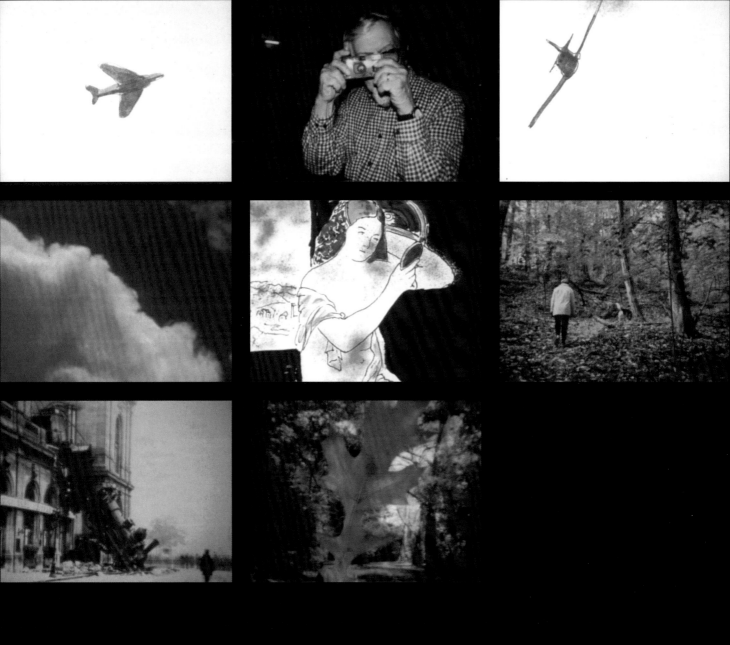

Stills from the film *What Goes Up?*, 2003

left:
Drawings for the film *What Goes Up?*, 2003

Mutoscopes

From the end of the 1950s to the first half of the 1960s – while Breer was making movies alongside further flip books – some devices with the titles *Folioscope* or *Mutoscope* came into being. In 1959 he showed some of his Mutoscopes in the 'Vision in Motion' exhibition in the Hessenhuis in Antwerp, one of a number of important early exhibitions at which some artists tried to define a common visual language for kinetic art, including members of the German ZERO group, some of the later French Nouveaux Réalistes such as Yves Klein and Daniel Spoerri, and other artists like Pol Bury, Jesús Rafael Soto and Bruno Munari.[1]

Essentially, Breer's Mutoscopes are carousels with sheets of paper or cellophane mounted to their axles, which automatically flip over when the hand-crank attached to the axle is wound. They are a type of mechanised infinite flip book using the effect of a rapid succession of pictures to create the illusion of a continuous, almost filmic picture sequence.

After Breer returned to the U.S. in 1959 he built further Mutoscopes. One of the surviving pieces, called 'Homage to John Cage', was made in 1963. The image-turning mechanism of this work is mounted on an ornate metal base. On his return to New York Breer settled in quickly and became part of the booming and lively art scene shaped by younger artists such as Robert Rauschenberg, Jasper Johns and Andy Warhol, and influenced by older ones such as Marcel Duchamp or John Cage, the subject of Breer's homage.

Another object that also examines the idea of visual illusion is *Dot Dash*, from 1964, a kind of two-sided Mutoscope that turns a fast-spinning piece of white wood, with a dot painted on one side and a line on the other, into a vibrating visual phenomenon.

1 Even though Jean Tinguely was featured on the exhibition poster, his work wasn't shown due to an argument with Paul Van Hoeydonk.

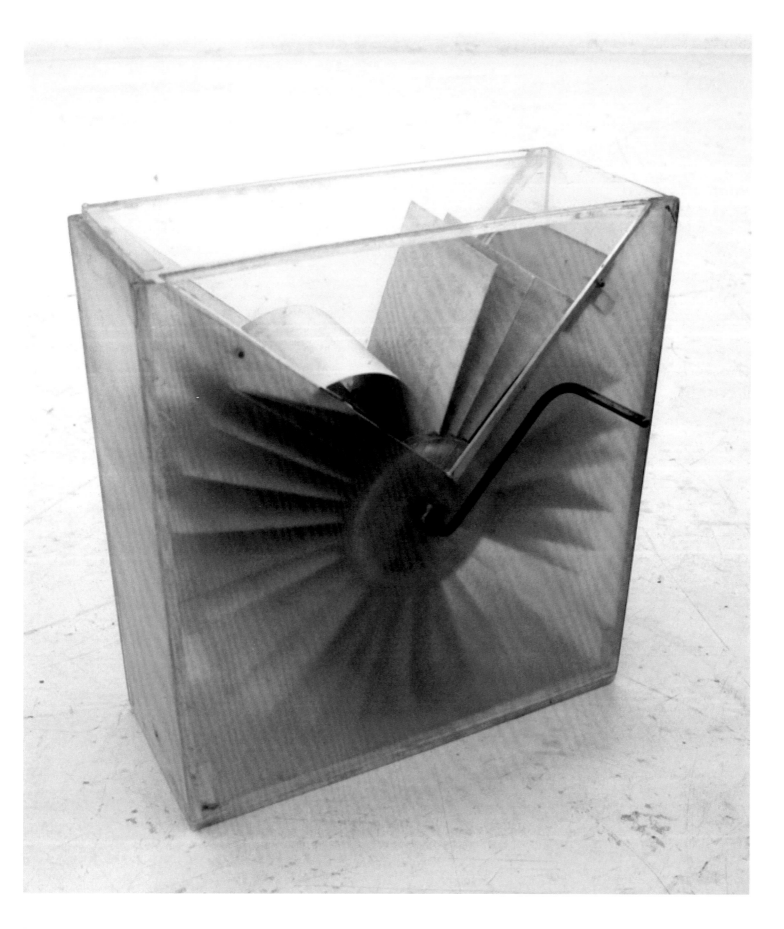

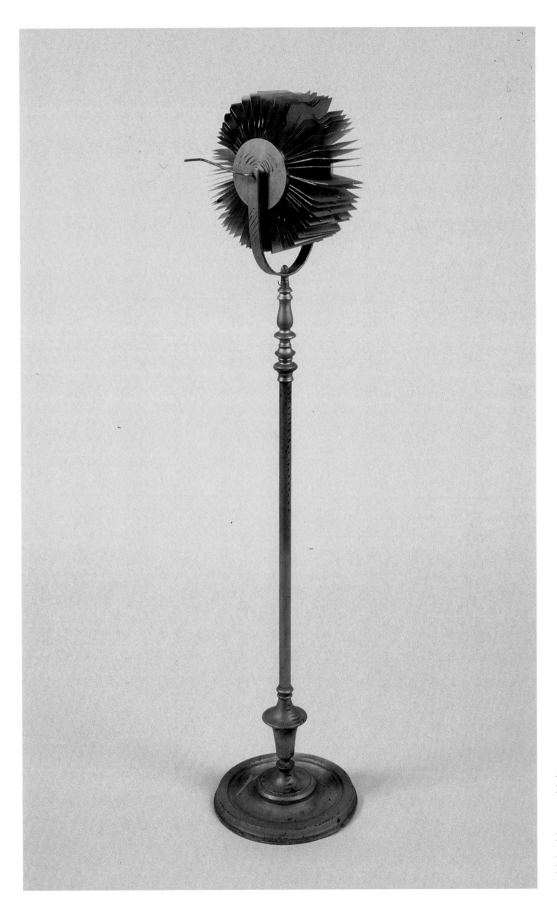

Homage to John Cage, 1963
Folioscope, plastic, metal, acrylic paint
112 x 25 cm

Page 79:
Folioscope, 1964
Mutoscope, plastic, metal
16.5 x 6.4 x 17 cm

Mural Flip Book, 1964
Wood, metal, paper
56 x 117 x 12.5 cm

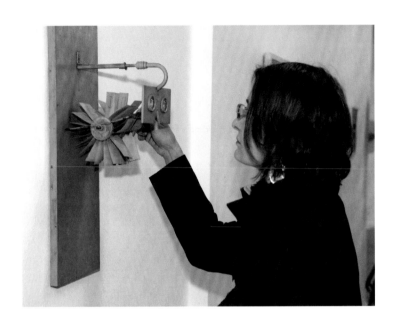

3 D-Mutoscope, 1978–1980
Wood, paper, glass
56 x 20.5 x 23 cm

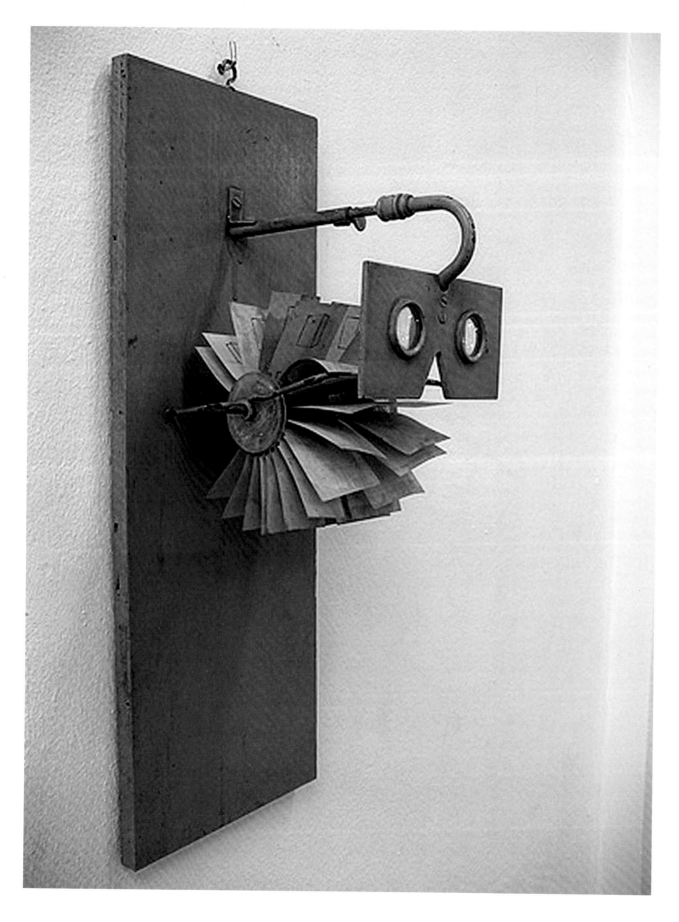

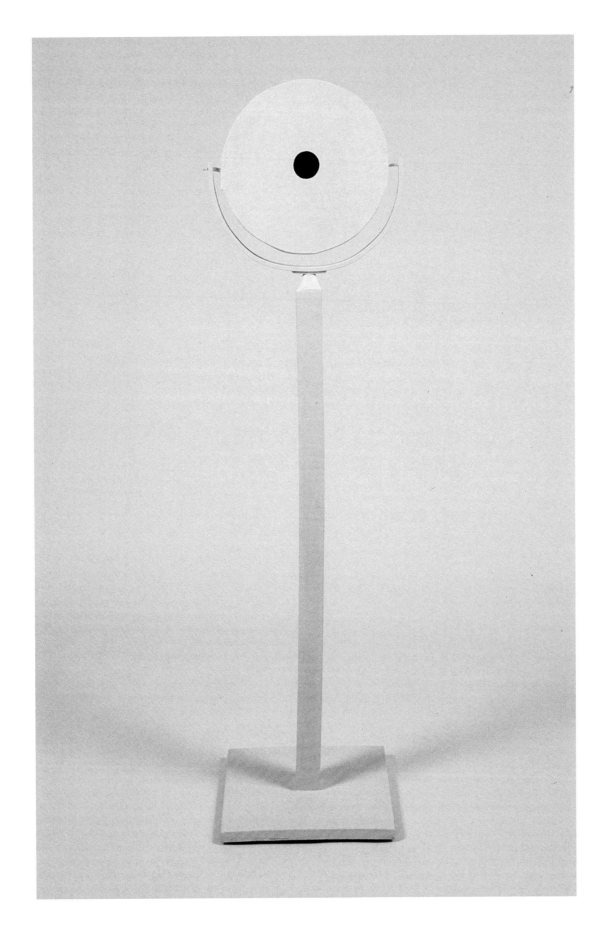

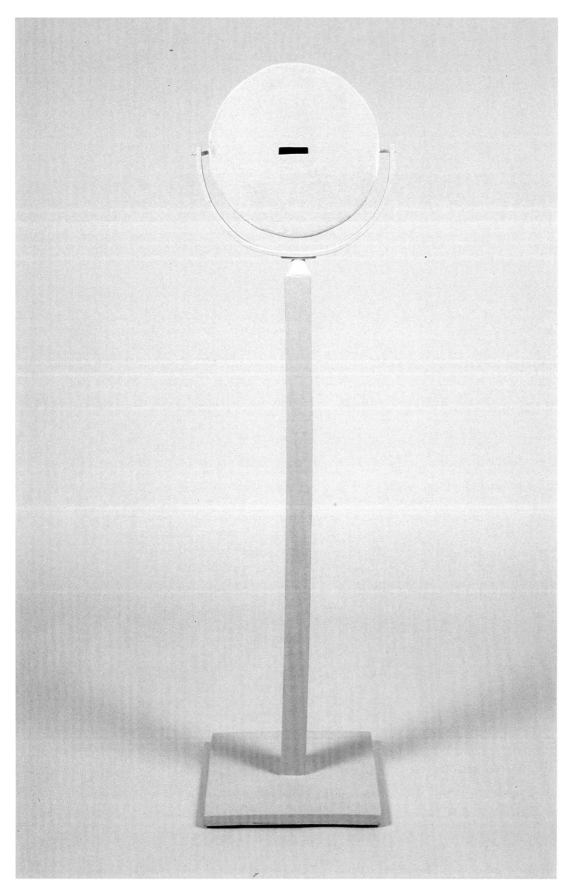

Dot Dash, 1964
Traumascope, wood, metal, paint
121.9 x 30.4 cm
Collection Musée Chateau d'Annecy

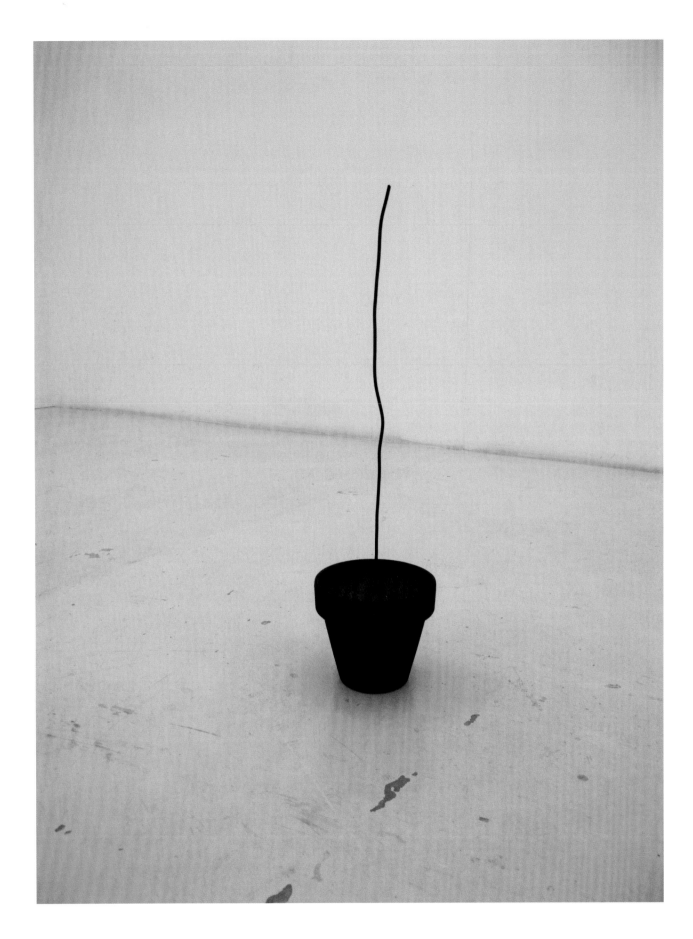

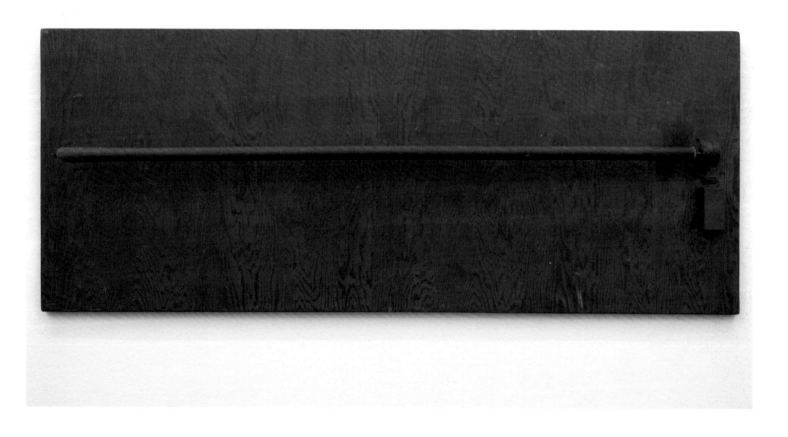

Rotating Broom Stick, 1964
Wood, metal, motor
19 x 48 x 4 cm

left:
Untitled (Flower Pot), 1962
Painted metal, metal rod, flower pot, motor
60 x 14 x 14 cm

Floats

In the mid-1960s Breer built the first *Floats:* slow-moving sculptures that float through a room and give a whole new dimension to the idea of sculpture. Breer always stages his *Floats* as groups of sculptures in ever-changing relationships with each other. 'I think of the entire armada as a single field – a composition that constantly rearranges itself. I'm not interested in the surprise the floats provide, but in your gradual awareness of their movement and their changing relationships.'[1] The designs of the various *Floats* differ greatly. They are abstract forms carved from Styrofoam that in some respects look as if they are a three-dimensional recreation of motifs from Breer's early paintings. They are only very rarely geometrically regular constructions as, for example, with *Tank* (1966), or the cylindrical *Floats*, created in 1972 for the Hammarskjöld Plaza in New York. Mostly, the *Floats* are irregularly shaped, like the long-rectangular *Switz* (1965), which is reminiscent of a Swiss cheese with its many cut-away holes, *Porcupine* (1967) that does indeed look like a porcupine with its quills, or the late *Float* titled *Loaf* (2007), which in shape and colour is reminiscent of a loaf of bread.

Rugs, constructions covered in black or silver foil that, on the one hand, move around and on the other contract and expand, hold a special place among the *Floats*. They don't just move around; because of their inner movements they appear to be much more animated and alive than the other Floats – almost breathing.

Wall is one of the most recent works in the exhibition and consists of a corner in a room about 3 x 4 metres in size. The entire wall moves around very slowly, almost indiscernibly, thus continuously altering the room that surrounds it. And this is one of the important aspects of the *Floats:* their effect on the room, which is not merely visual but also directly physical.

1 Robert Breer in: *The New York Times*, 20 February 1966.

Switz, 1965
Polystyrene, motor
12 x 13 x 60 cm

Untitled, n.d.
Drawing on paper
12.5 x 20.2 cm

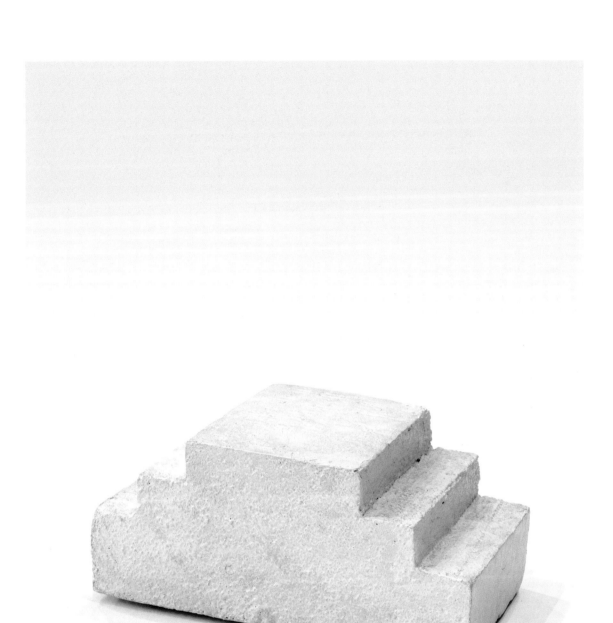

Zig, 1965
Polystyrene, motor
16 x 20 x 35 cm

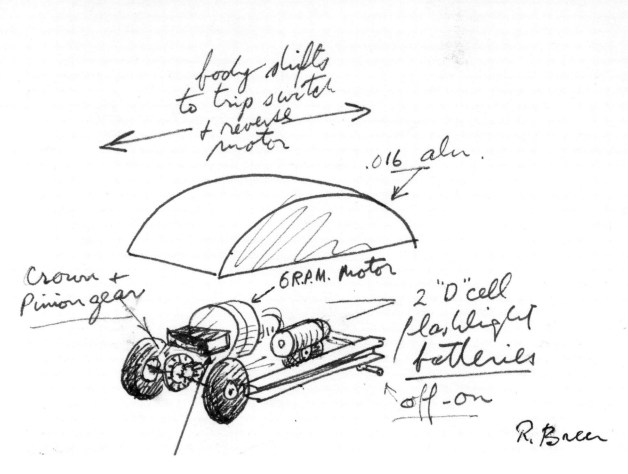

body shifts
to trip switch
+ reverse
motor

.016 alu.

Crown +
Pinion gear

6 R.P.M. Motor

2 "D" cell
flashlight
batteries

off - on

R. Breer

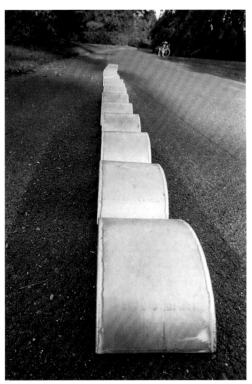

Untitled, n.d.
Drawing on paper
12 x 17.5 cm

Self Propelled Aluminium Tanks, 1967

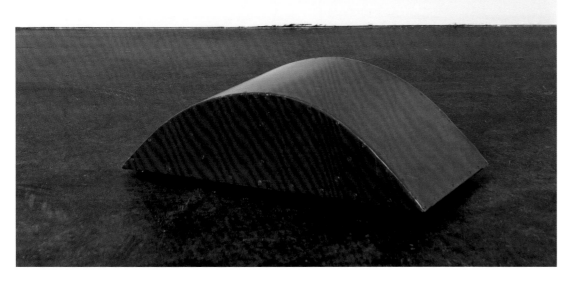

Tank, 1966
Painted metal, Styrofoam,
motor, wheels
14 x 24 x 48 cm

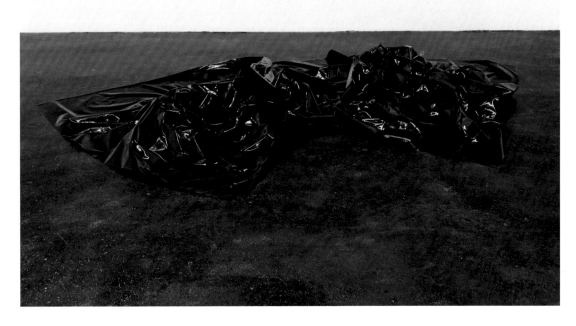

Rug # 5, 1965
Plastic cover, two motors
Dimensions variable

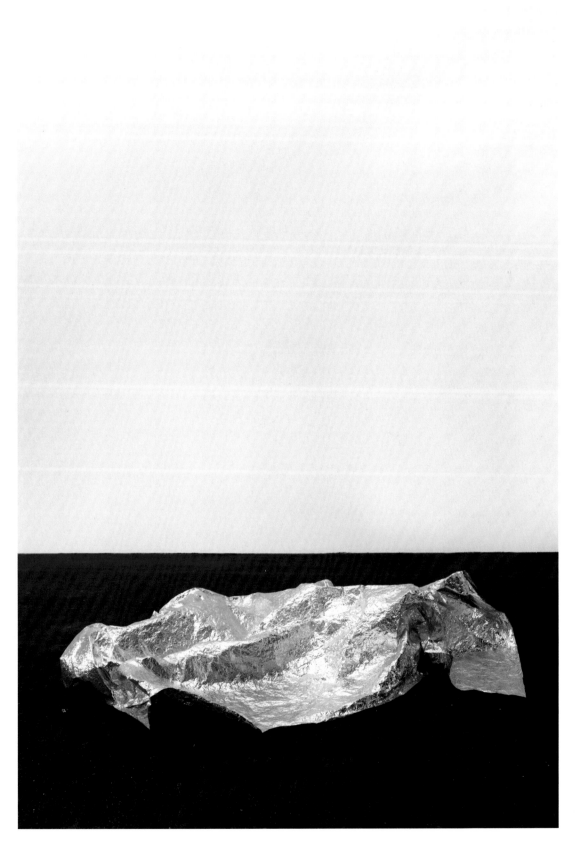

Rug, 1966
Aluminium cover, three motors
Dimensions variable

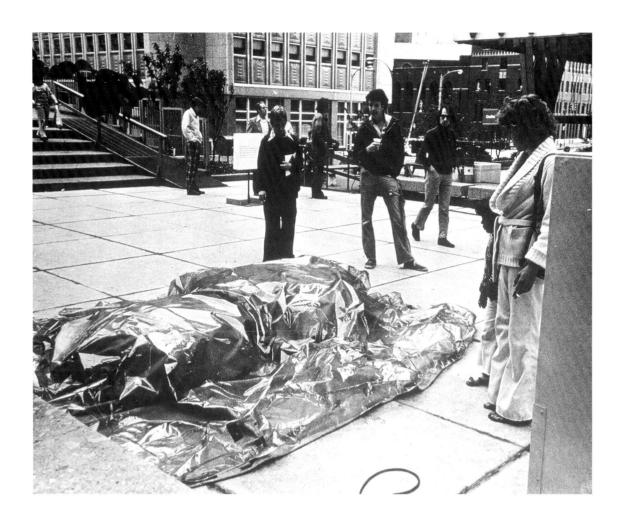

Rug at the IBM Plaza, Pittsburg, 1974

right:
Float Porcupine, 1967
Foam, matchsticks, motor
18 x 33 x 51 cm

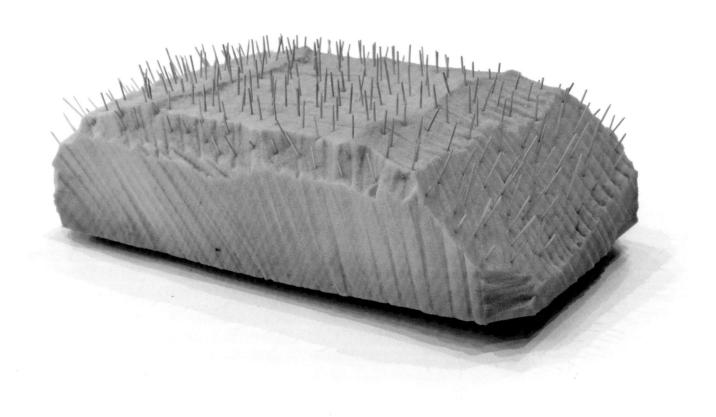

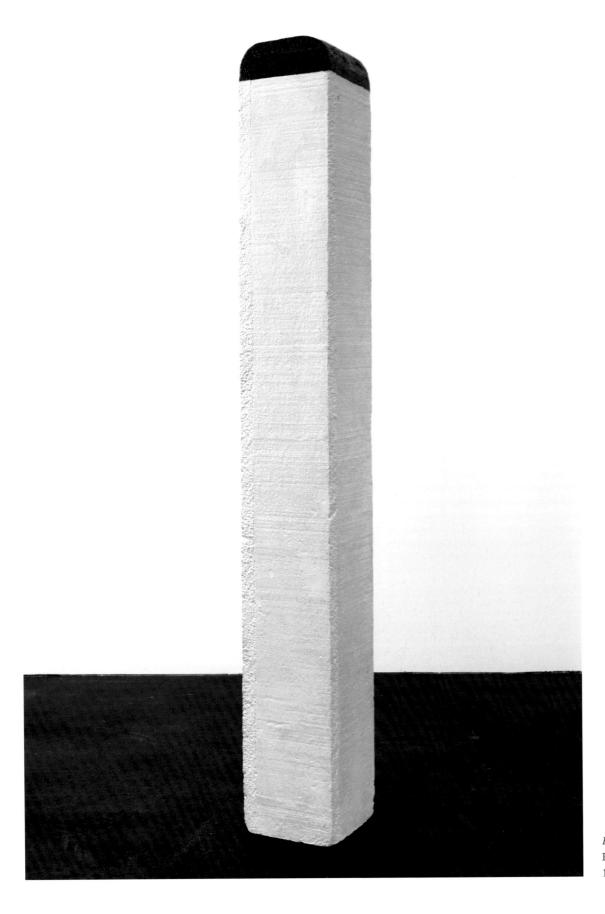

Borne, 1967
Polystyrene, motor
142 x 18 x 18 cm

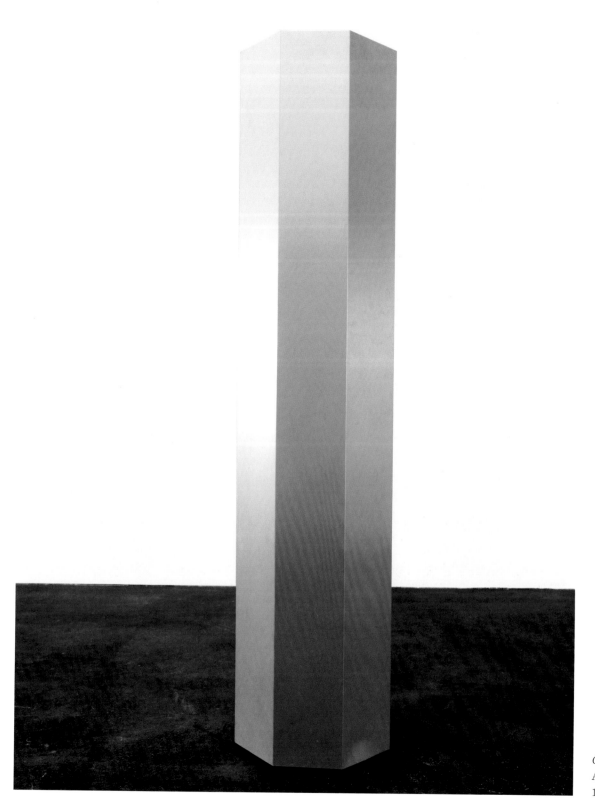

Column, 1967
Aluminium, motor
168 x 37 cm

Robert Breer – Floats
On Sculpture without a Place

Andres Pardey

Robert Breer's *floats,* in existence since the 1960s, move. In the context of a retrospective of his work that will soon also come to Museum Tinguely in Basel, at first this statement appears to be of a simple banality that almost has no real message. Movement is no longer anything special in 21st-century art, and the use of motors, batteries, styrofoam, acrylic glass or fibreglass-reinforced polyester might well agitate some restorers but certainly not the modern art viewer. However, there is a particular aspect to the movement of Breer's *floats* that allows them to become special, even unsettling, entities. It is not as if the sculptures have moveable parts, as if they were kinetic artworks that might wave an arm here or shake a mirror there; with Breer we are not talking simply about motion but about LOCO-motion. The sculptures constantly change their position in the room – and they do it by themselves, quietly, even silently, and, first and foremost, constantly. They are so independent that they need neither control nor controller – they *float* around the exhibition space (which in some instances may be an outdoor square or a terrace) all on their own, and, because they go about their business so quietly and slowly, we don't notice their movement directly unless we observe them closely and consciously. What is so irritating about the whole affair is the very fact that sculptures that, a minute ago, were over there are now over here...

Another aspect needs to be mentioned, something that is a condition for moving around, but is worth exploring in the context of sculptures: Robert Breer's floats stand directly on the floor, without any pedestal. This, of course, has to do with their movement – but neither did Breer use a sculptural-architectural type of pedestal.

There is only the sculpture that stands directly on the floor – on the same floor, therefore, on which the viewer also moves around. And sometimes the *floats* seem to react as if subconsciously to the viewer's movements. A traditional sculpture is primarily a corporeal work: the only one of the three main visual art forms (the others being painting and graphics) that expands into the room, that is three-dimensional. It can be carved, chiselled – *sculpted* – or else cast or modelled. It can consist of the classic sculptor's materials such as stone, bronze or wood, or, as witnessed increasingly in the past hundred years, can consist of materials such as cardboard, wax, polyester or a great variety of metals from iron to lead. And it can also consist of a combination of materials, can be put together from obviously found articles into an assemblage or can even be composed of scrap metal and waste. But all these very different types of sculptural artworks have one thing in common: often, they are placed on a pedestal. Assuming they're not too big, this raises them to a viewer's eye-level; it also protects them from viewers' feet and cleaners' mops. Therefore pedestals have a mainly practical function, quite apart from their immensely important role in the functioning of the sculpture, which is free-standing and does not have a defined place per se in the room (as opposed to a painting, for example, whose defined place is a wall). Pedestals 'give' sculptures their place; their size helps define the sphere of a sculpture, and they enable a dialogue with the art at eye-level – or else awe viewers by elevating the sculpture above them. Pedestals put sculptures into a relationship with the space around them, creating a grid of sight-lines relating to passages, windows, paintings on the wall and other sculptural works. With their choice of

colour and size they allow the creators of an exhibition to influence the effect of the exhibited sculpture to a far greater extent than is possible simply with its placement in the room. Naturally artists take measures to prevent this, issuing guidelines for pedestal designs; nonetheless both placement and neighbouring artworks are ultimately matters of curatorial choice – or, in the case of sculpture in public spaces, choices of the town/city architect.

Even when a sculpture moves – when it is a kinetic sculpture – it usually stands on a pedestal. After all, only some part of the sculpture moves, while the work as a whole remains in the same place and should, above all, be well and appropriately presented just like any other sculpture. Even though kinetic works make use of the design principles of 'time' and 'change', even though they overcome the traditional motionlessness of the artwork, they still usually stand on a pedestal.

There are exceptions, of course – deliberate or otherwise. One of the earliest notable exceptions was attempted in 1884–1886, when Auguste Rodin wanted to place his *Burghers of Calais* directly onto the cobblestones of the town-hall square of the northern French town, so the inhabitants might have a direct dialogue with the 'Burghers', helped by their only slightly larger than life size and their arrangement. However, this idea was rejected. Rodin had this to say: 'You noticed especially the way I distributed heroic courage variously between my "Burghers". In order to emphasise this effect even more, I expressed the wish that the statues should be set on the paving stones of the square in front of the Hôtel de Ville in Calais like a living chain of suffering and self-sacrifice. They might then have looked as though they were

leaving the city hall in order to go to the camp of Edward III; and the Calaiser of today would have felt more deeply through such intimate daily contact with their ancestors an emotion of belonging that would have bonded them with their heroes [...] But they rejected my plan and insisted on an ugly and superfluous pedestal.'[1]

Various other artists looked for ways to redefine the function of the pedestal or to make it a part of the artwork. Constantin Brancusi, for example, treated the pedestals as part of the work by sculpting them in the same way as the artwork. Other artists left out the pedestal altogether and placed the sculptures on the floor like boulders. Alexander Calder did not use pedestals at all – or rather he avoided the problem by suspending his mobiles from the ceiling. The *stabiles* stood, if they were big enough, directly on the floor. This was the chosen solution for many 20th-century sculptors; for them the floor of the exhibition space, and consequently the exhibition room itself, became the pedestal that gave a sculpture its place to unfold. The viewer now stood on the same level as the artwork. To talk about democratisation may be a little far-fetched, but the borders between work and viewer were certainly broken down somewhat, perhaps allowing simpler, more direct access to the arts. This aspect – one of the overriding motifs in 20th-century art – inspired many a choice between pedestal or floor sculpture. Of course, most installations or spatial situations are conceivable only without pedestal, but by the same token many sculptures were created over the past decades that were clearly meant to be placed directly on the floor – often because, following Brancusi's example, the pedestal was an integral part of their design.

Alternatively artists saw the floor itself as a pedestal for their work, such as Ulrich Rückriem who, in 1977, stated: 'A large vertical mass of stone divided into horizontal parts appears to me much heavier than without any division. The horizontal of the floor then becomes part of the division and presses downwards at the same time. Something that is divided vertically appears as if it is falling apart. The floor on which the piece stands is a pedestal and influences the piece.'[2]

There have, however, always been declarations in favour of the pedestal, such as that of A.R. Penck in 1986: '[The function of the pedestal is] first and foremost to isolate, to remove from reality: to make the sculpture special through its pedestal, to create a distance. Rather than just have it standing there, I use the pedestal as a creation with its own meaning and at the same time a function with regard to proportion. But then again, in many ways I fight its conventionality.'[3] At the same time Penck's declaration in favour of the pedestal is (and this appears to be a common phenomenon) a declaration of war. The effect of the pedestal, its working in favour of convention, perhaps even the sublimation of the work presented on top of it, is only one of many possibilities in contemporary art, and is often the one that needs to be questioned or even combated. The direct, barrier-free and therefore often also pedestal-free access to the artwork has become far too important.

Robert Breer wrote in 1967: 'My *floats* creep along the floor imperceptibly. Sometimes they seem to be rising or expanding instead of moving horizontally. To me it was important only that they have some life of their own – and to give them mobility seemed the best solution. I am not particularly interested in demonstrating motion as such and have deliberately kept my pieces monolithic. There are no visible moving parts. Movement only takes place outside the piece, between it and the surrounding space and thus becomes part of the atmosphere, like light.

Though they are often referred to as creatures and I enjoy their animal-like autonomy, they have grown out of abstract notions and ideally refer back only to themselves or the environment they create.

These almost motionless *floats* occupy the same threshold I've crossed over thousands of times in making my animated films. It's a question of putting two and two together and getting five.'[4]

What is remarkable about this statement is that Breer attributes to his moving sculptures a life of their own, almost a personality, even. They straighten up, they move around the room autonomously and they enter into a dialogue with the surrounding nature and architecture, with light and atmosphere. They become part of the whole and reshape it constantly. For Breer, movement was the most adequate means of achieving this and the *floats* do indeed behave accordingly. They live.

This changes the role of the viewer completely from the one assigned to him in front of an immovable statue or, in fact, in front of a kinetic work. Not only do the viewers stand – because of the missing pedestal – on the same level as the work, but the artwork also competes for their (living-)space. Breer's floats claim, as a matter of course, the same space occupied by the viewers, and they compete with them for standing space and therefore, as such, their place. Other sculptures may reach out into the room using movement, light projection or water

features, but the *floats* take over the entire room. They do not reach out – they take possession. In this respect, Breer's *floats* might be more readily compared to room-filling installations than to fixed sculptures, with or without pedestal.

Where Heinz Günter Prager wrote, in 1978, 'Sculpture cannot be experienced without the viewer's physical involvement (walking, running, striding), because what changes the object "sculpture" and the subject "human" is the constantly changing distance between the two, the constantly changing perspective. Human and sculpture are fixed entities'[5], Breer practically turns this insight on its head. It is not human and sculpture that are now stable, but rather the room that functions as the only fixed reference point. Only the room is continuous, and only under the premise that the factor 'time' as a determining element in experiencing the room is not taken into consideration for the time being. Human and sculpture are both in motion, the sculpture from within itself, the human as a reaction to the autonomous movements of the sculpture. The human has to sidestep the sculpture, is forced to find new places to stand and new places from which to view because of the forever-changing constellations in the room. The room remains untouched by all this, but the view onto the room, and therefore onto the artworks (and viewers) moving around within it, changes constantly. In this ever-new experience, the viewer's perception of the room must also change – becoming something momentary that progressively loses its grip on the continuity that was at first expected. Everything is now fluctuating; everything is just a snapshot, a moment in time.

In this way the art becomes a part of the room, of time, and of the viewers themselves, who in turn, through being at the mercy of the sculptures' movements, have to become part of the artwork in a room or place 'inhabited' by *floats*. They become participants, but in a mostly reactive role. They become part of a system, as described by Hans Haacke: 'A "sculpture" that physically influences its *environment* and/or its surroundings, can no longer be seen as an object. The entirety of the external factors that influence it and its sphere of influence reach beyond the space that it physically fills. It merges with its *environment* into a relationship that can be better understood as a "system" of interdependent processes. These processes – transmission of energy, matter or information – develop without the viewer's empathy. In works that were conceived for a participating audience, the viewer may be the energy source. His mere presence might be all that is needed here. There are also "sculpture" systems that work with no audience present at all. In none of these instances, however, does the emotional, perceptual or intellectual response of the viewer have any effect on the behaviour of the system. This independence does not allow him to claim his traditional role, as if he were master of (the significance) of the sculpture; instead, the viewer becomes more of a witness. A system is not imagined; it is real.'[6]

Haacke's statement describes in a relatively radical manner the process that takes place in front of Robert Breer's *floats*. Only because they are slow, and therefore gentle, are these sculptures lacking in the threat that resonates through Hans Haacke's text. Breer's sculptures are friends, but friends who do exactly as they please. They do, however, enter into a dialogue with the viewer. And

they are practically waiting for this dialogue, because, for them, Carl Andre's statement holds true: 'I think the work is only complete once someone comes along and makes a work of art out of this work of art'[7] ... or becomes a part of the artwork in the room.

1 *Auguste Rodin. Die Kunst.* Gespräche des Meisters gesammelt von Paul Gsell, Munich 1920, p. 65 ff.; quoted here from Edouard Trier, *Bildhauertheorien im 20. Jahrhundert*, Berlin 1992, p. 165.

2 Hannelore Kersting (ed.), *Texte über Rückriem 1964–1987,* Düsseldorf 1987, p. 129; quoted here from Edouard Trier, *Bildhauertheorien im 20. Jahrhundert*, Berlin 1992, p. 170.

3 *Raumbilder in Bronze. Per Kirkeby, Markus Lüpertz, A.R. Penck,* exh. cat. Kunsthalle Bielefeld, 1986, p. 144; quoted here from Edouard Trier, *Bildhauertheorien im 20. Jahrhundert*, Berlin 1992, p. 171.

4 Robert Breer in: *Art International*, vol. XII, February 1968, p. 45.

5 Heinz Günter Prager, *Skulpturen 1967–1978,* exh. cat. Städtische Museen Leverkusen, Schloss Morsbroich, 1978, p. 146; quoted here from Edouard Trier, *Bildhauertheorien im 20. Jahrhundert*, Berlin 1992, p. 240.

6 Germano Celant (ed.), *Ars povera*. Tübingen 1969, p. 179; quoted here from Edouard Trier, *Bildhauertheorien im 20. Jahrhundert,* Berlin 1992, p. 245.

7 Studio International, London 1970, p. 175; quoted here from Edouard Trier, *Bildhauertheorien im 20. Jahrhundert,* Berlin 1992, p. 243.

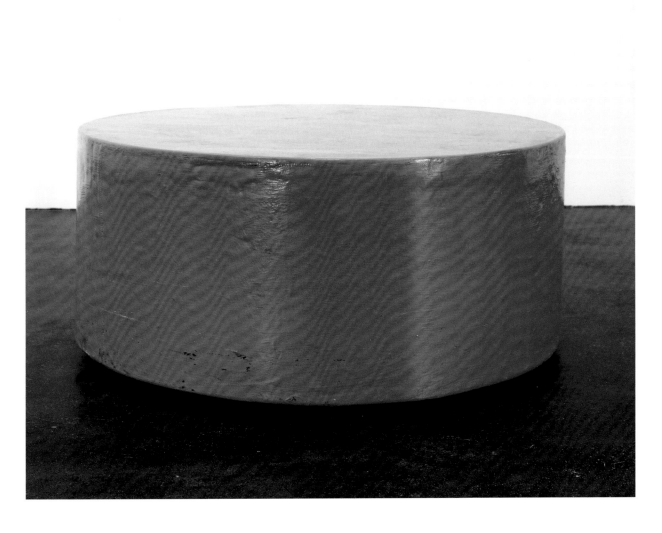

Page 105:
Float (Hammarskjold Plaza), 1972
Polyester, paint, wood, motor, wheels
41.8 x 92.8 cm

Float, 1972
Polyester, paint, wood, motor
50 x 100 cm

Float, 1972
Polyester, paint, wood, motor
50 x 100 cm

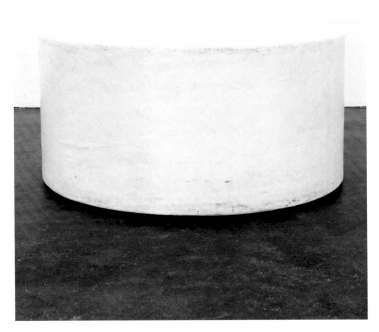

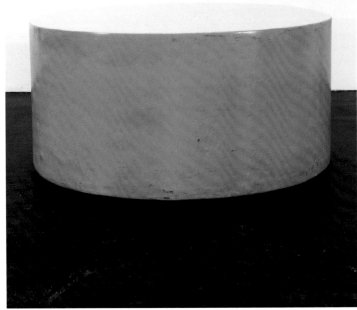

Pages 108/109:
Floats in the exhibition *Robert Breer. Floats*
CAPC, Musée d'Art Contemporain, Bordeaux, 2010

Pages 110/111:
Float, 1970
Fiberglass on steel chassis, electric motor, car battery
180 x 180 cm

2 Hammarskjold Plaza, 1973
Photograph of a drawing
21.5 x 28 cm

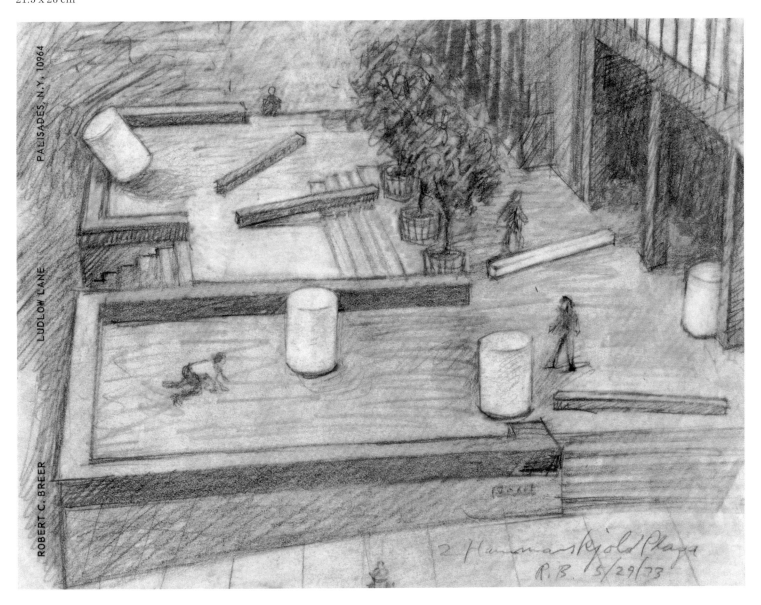

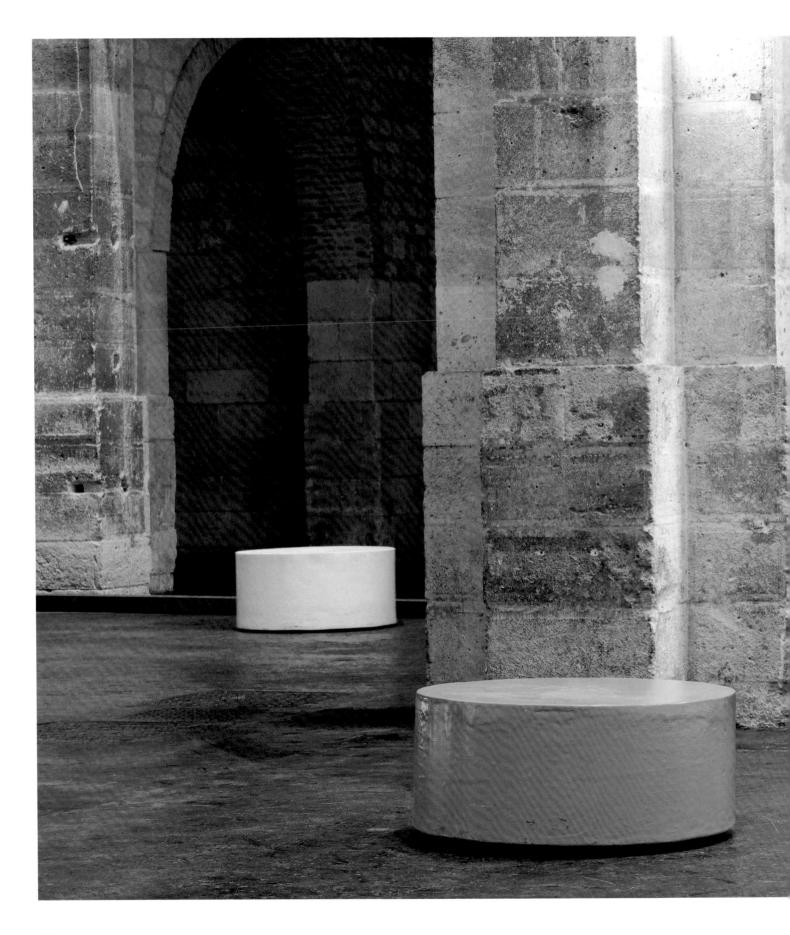

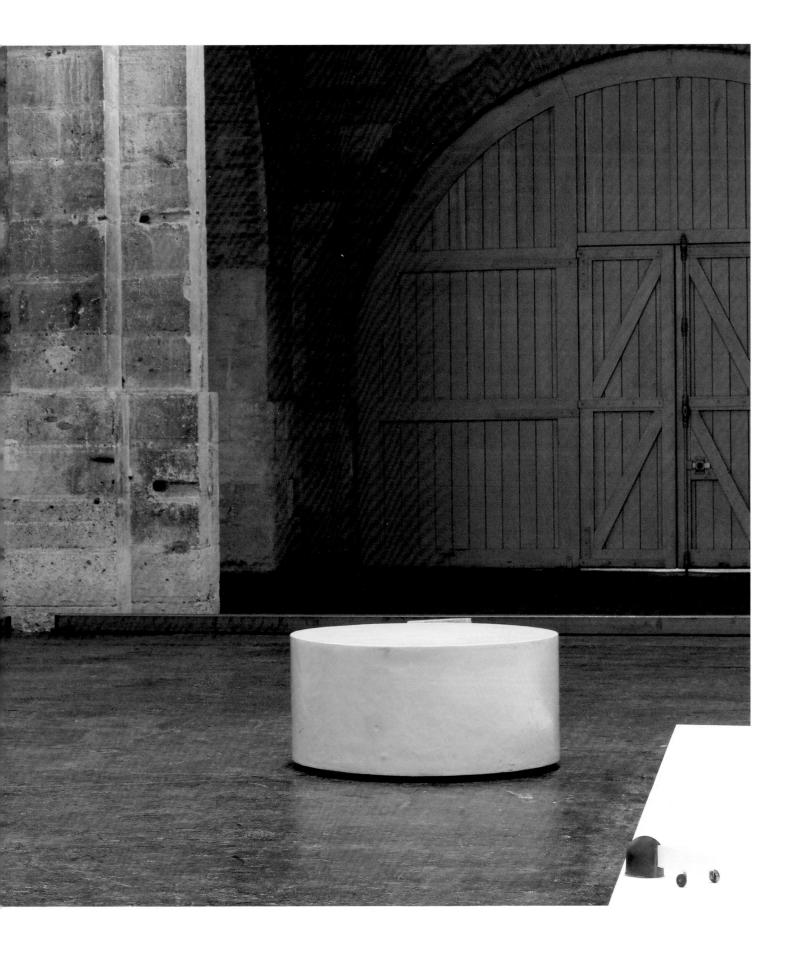

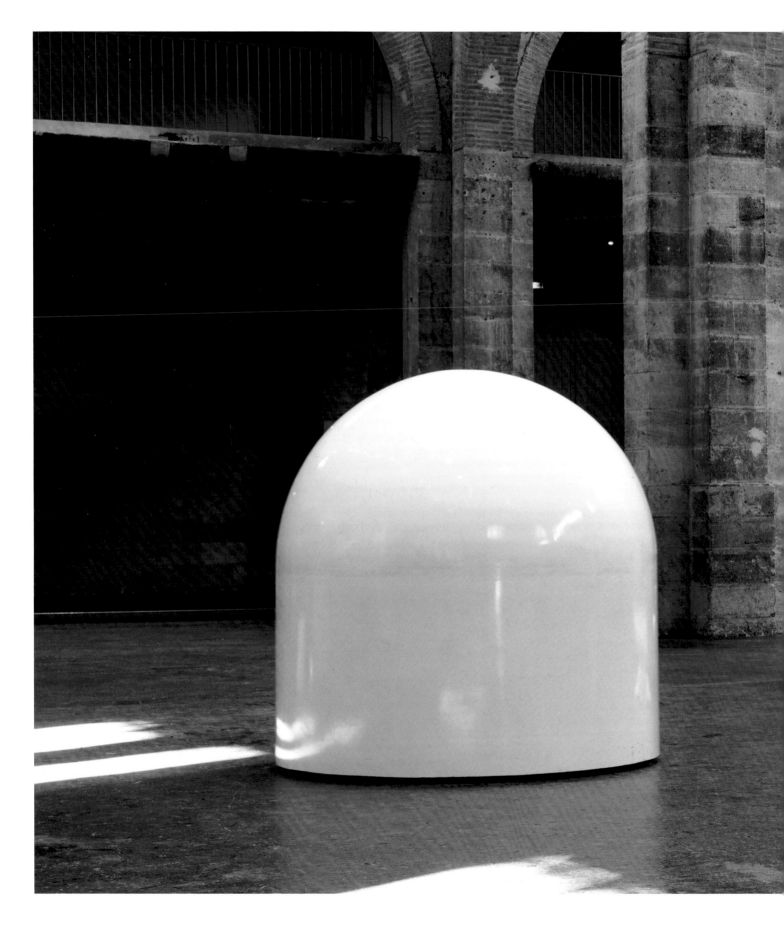

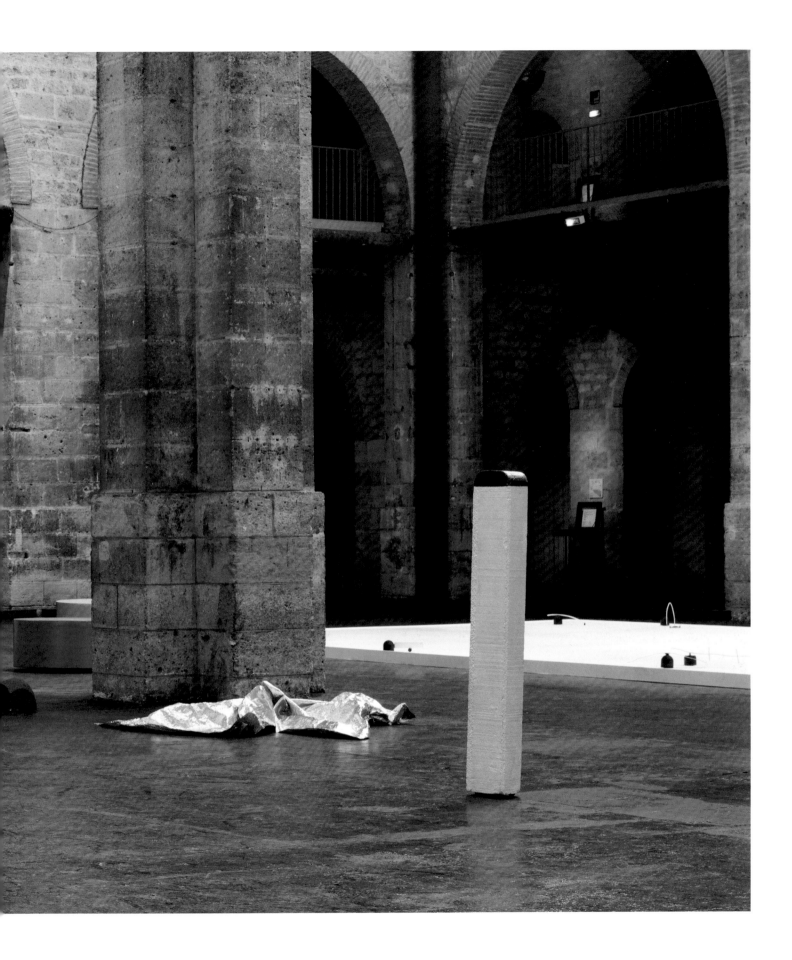

Floats: Osaka, Pepsi-Cola-Pavilion

In 1970 Robert Breer was one of the four artists who, alongside Billy Klüver, were at the centre of the organisational team for the Pepsi-Cola-Pavilion at the World Exposition in Osaka. Along with Frosty Myers, David Tudor and Robert Whitman he designed the pavilion that brought sculpture, environment, light and sound installations – a synthesis of the arts – together under the same roof. The overall organisation was managed by *E.A.T. (Experiments in Art and Technology)*, a project initiated in the mid-1960s by Swedish-American engineer Billy Klüver, together with Robert Rauschenberg, Fred Waldhauer and Robert Whitman, specialising in the interfaces of art and technology by supporting artists in realising their works. Apart from his involvement in the overall conceptual design, Breer's contribution to the pavilion was his construction of seven large *Floats:* sculptures nearly two metres high that moved around the outside terrace at a very slow, barely discernible speed. The project, which in the end involved approximately seventy-five artists and engineers, has gone down in history as a multidisciplinary artwork, as well as a classic example of collaboration between artists and engineers. Klüver's aim of enabling the participating artists to put their creative ideas into practice was realised in exemplary fashion. In particular, Fujiko Nakaya's fog sculpture that shrouded the building's roof in dense fog was an extreme technical challenge for the *Pavilion* team.

Breer's *Floats* were amongst the most widely observed elements of the *Pavilion*. With their slow movements and minimalist design, counteracted by the almost anthropomorphically slow movements around the area and the multitude of sounds emanating from them, they interacted with the visitors – just as Billy Klüver had intended: 'The initial concern of the artists who designed the *Pavilion* was that the quality of the experience of the visitor should involve choice, responsibility, freedom and participation. The *Pavilion* would not guide the visitor through a didactic authoritarian experience. The visitor would be encouraged as an individual to explore the environment and compose his own experience. As a work of art, the *Pavilion* and its operation would be an open-ended situation, an experiment in the scientific sense of the word.'[1]

1 Billy Klüver, *The Pavilion*, Dutton: New York, 1972, p. IX.

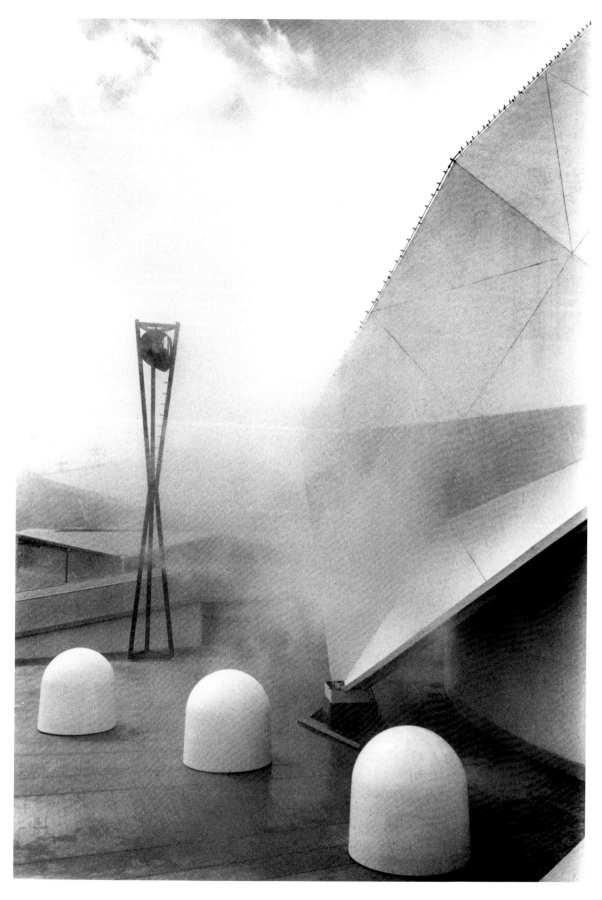

Floats at the Pepsi-Cola-Pavilion
Osaka 1970

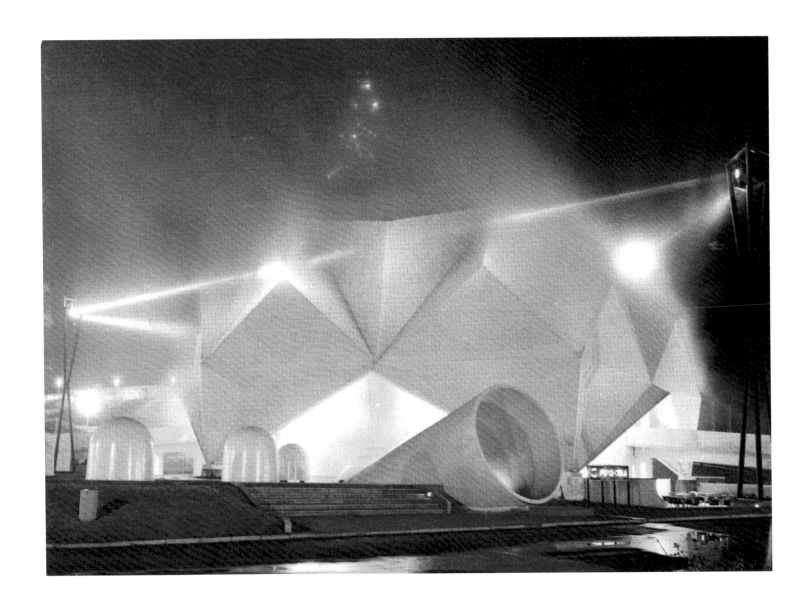

Pepsi-Cola-Pavilion, Osaka 1970

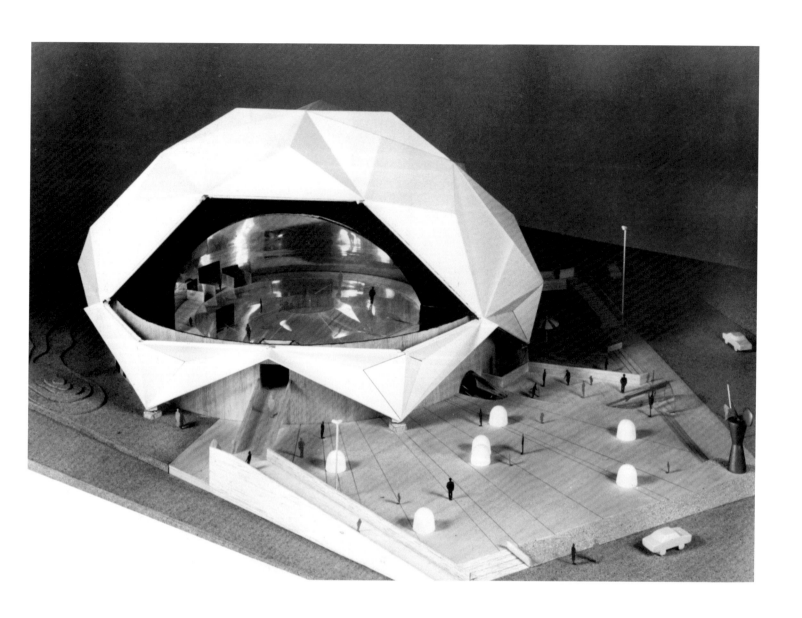

Model from the Pepsi-Cola-Pavilion, Osaka 1970

70, 1970
Seven original drawings on wooden panel from the film *70*
61 x 244 cm

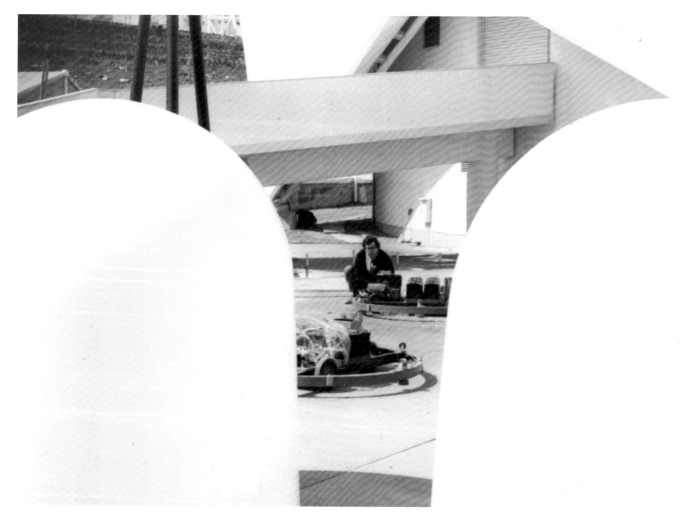

Robert Breer at the installation of *Floats*
in the Pepsi-Cola-Pavilion, Osaka 1970

70, 1970
Seven original drawings on wooden panel from the film *70*
61 x 244 cm

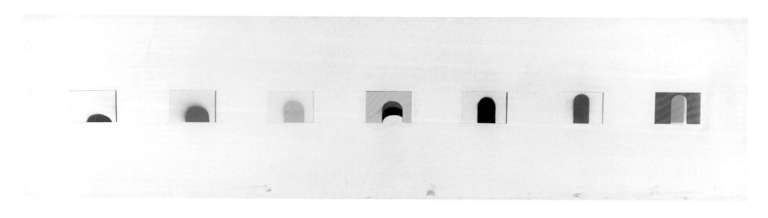

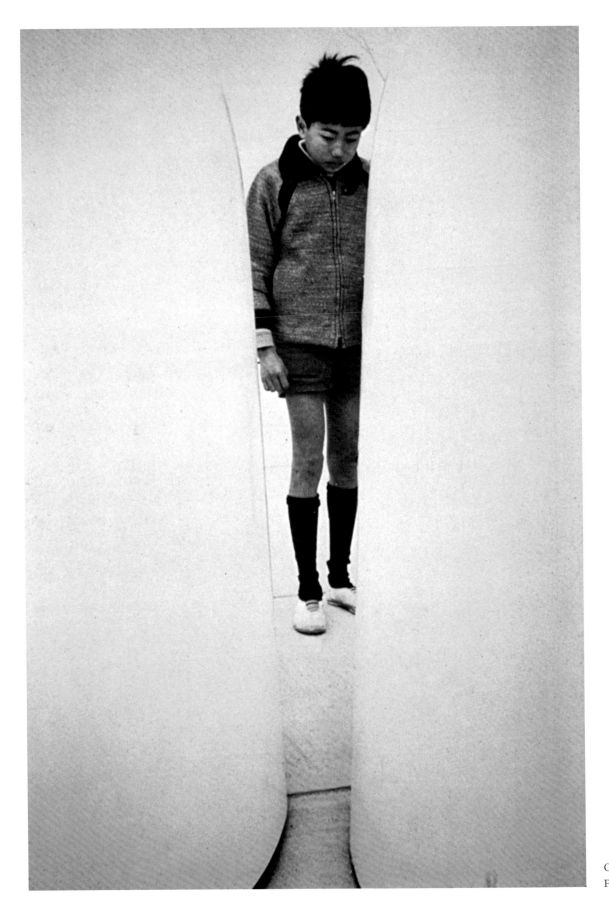

Child with *Floats*
Pepsi-Cola-Pavilion, Osaka 1970

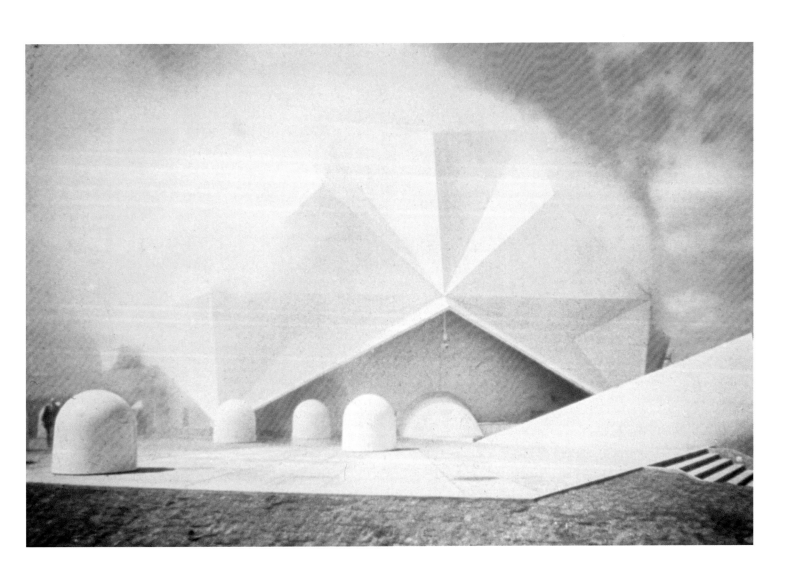

Floats at the Pepsi-Cola-Pavilion, Osaka 1970

Float in the exhibition *Robert Breer. Floats*
CAPC, Musée d'Art Contemporain, Bordeaux, 2010

Page 122/123:
Exhibition *Robert Breer. Floats*
CAPC, Musée d'Art Contemporain, Bordeaux, 2010

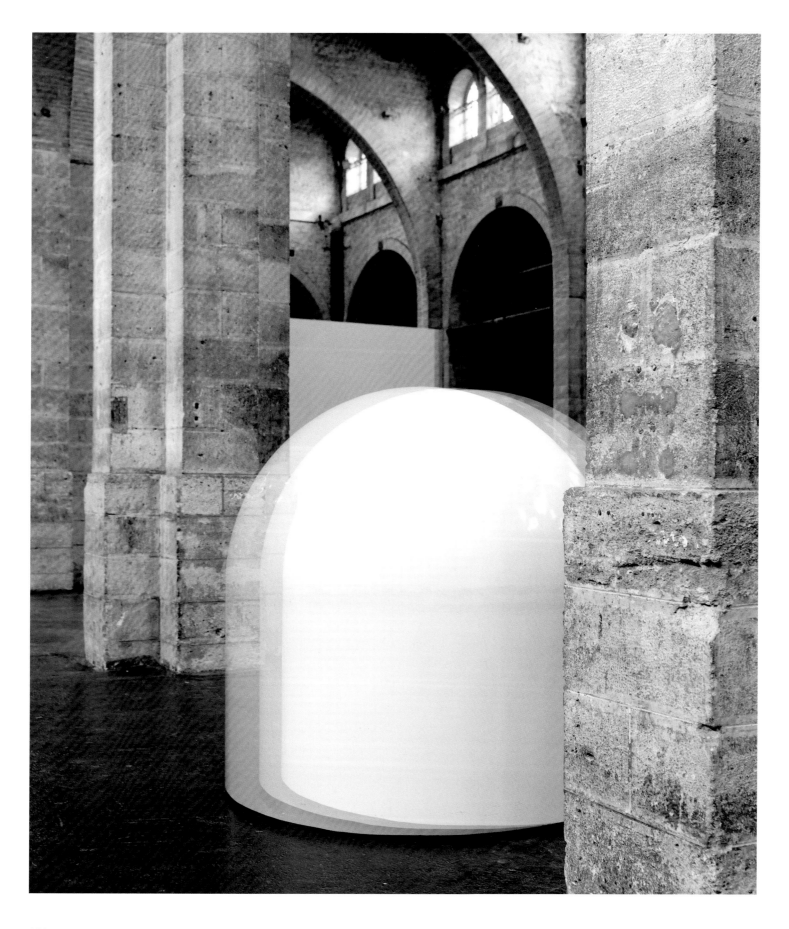

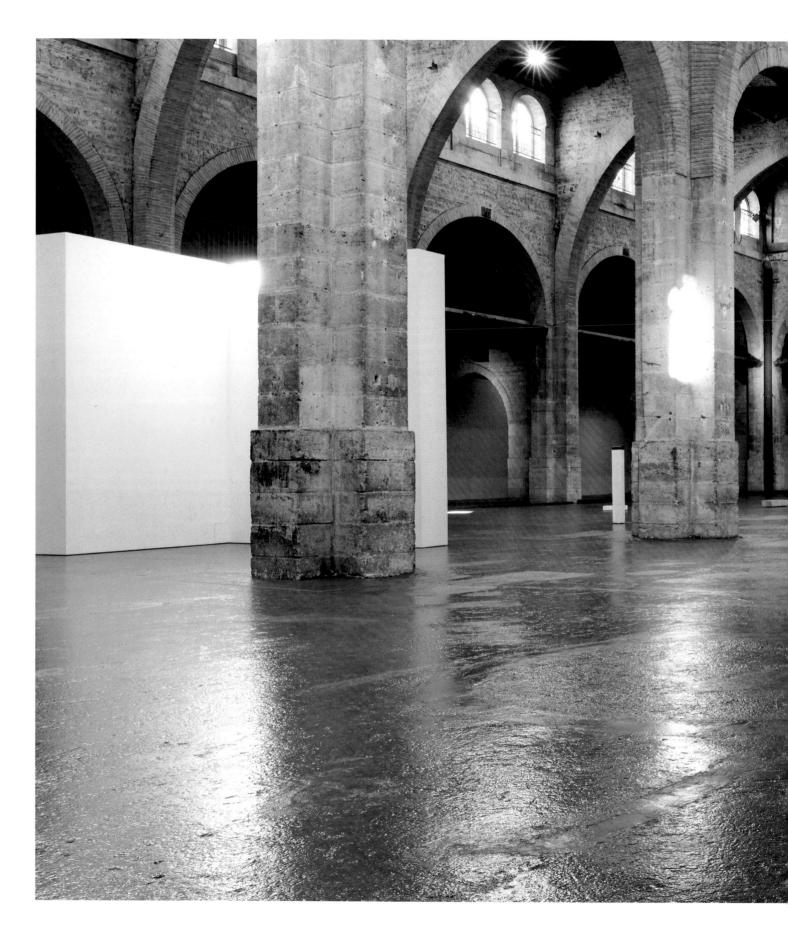

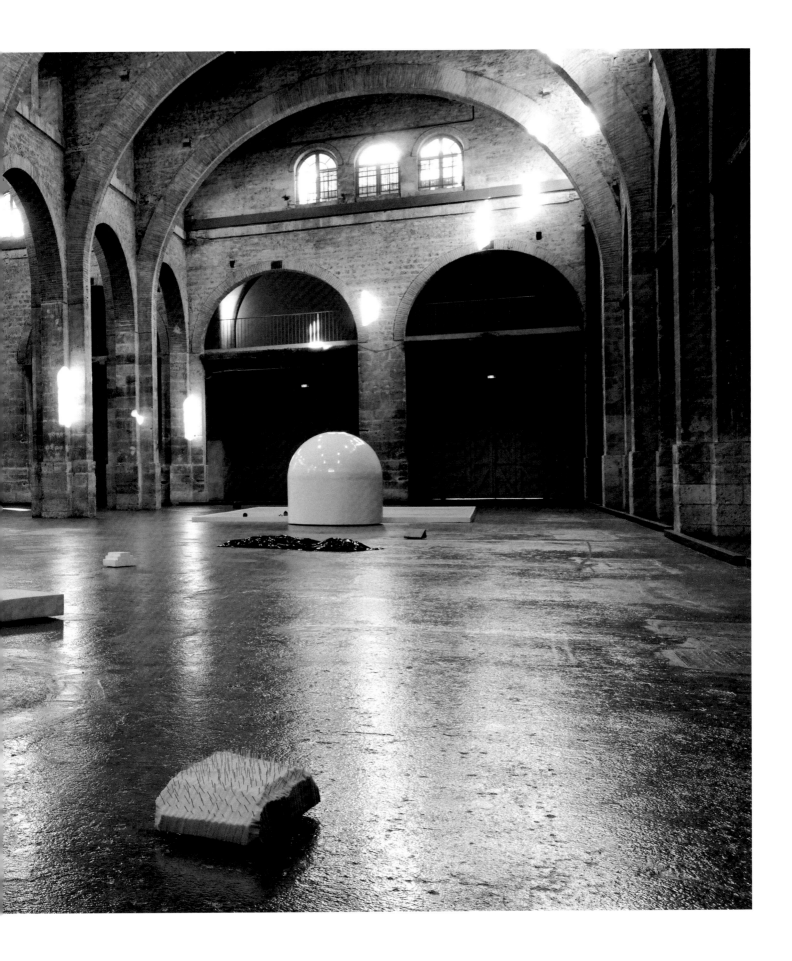

NASSAU INN
ON PALMER SQUARE · PRINCETON · N.J.

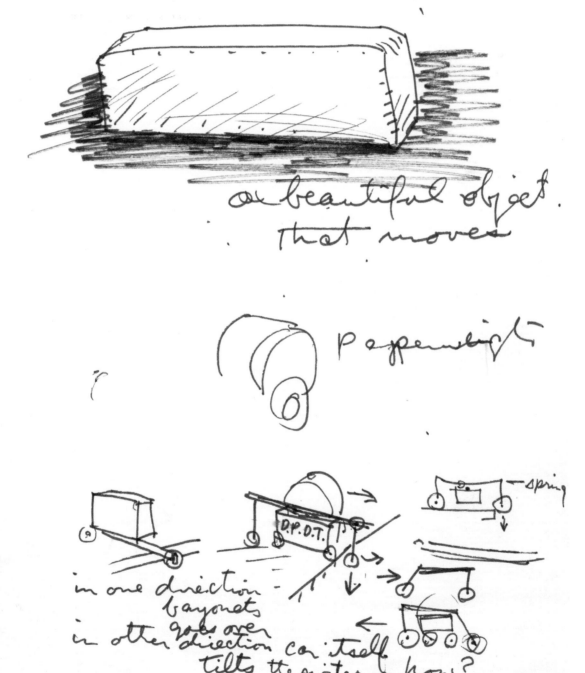

a beautiful object.
that moves

Paperweight

in one direction –
bayonets
in other direction
goes over
tilts the switer –
can itself
how?

spring

D.P.D.T.

Untitled, n.d.
Drawing on paper
26.5 x 18.3 cm

Sponge, 2000
Plastic foam, motor
15 x 62 x 65 cm

Sponge, 2000
Plastic foam, motor
17 x 100 x 37 cm

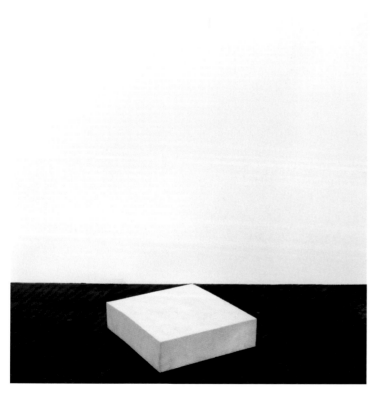

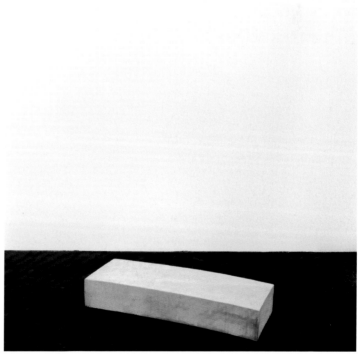

Slice, 2008
Painted Styrofoam, motor
19 x 18.5 x 21 x 10 cm

Silvercup, 2008
Painted Styrofoam, motor
20 x 20.5 x 14.5 cm

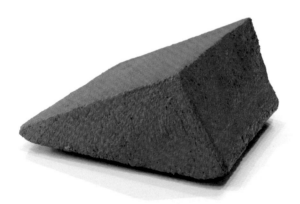

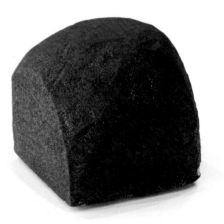

Loaf, 2007
Painted polyester, motor
80 x 60 x 100 cm

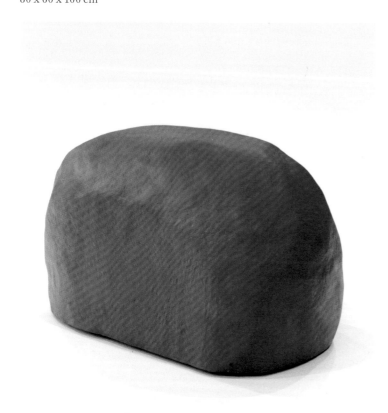

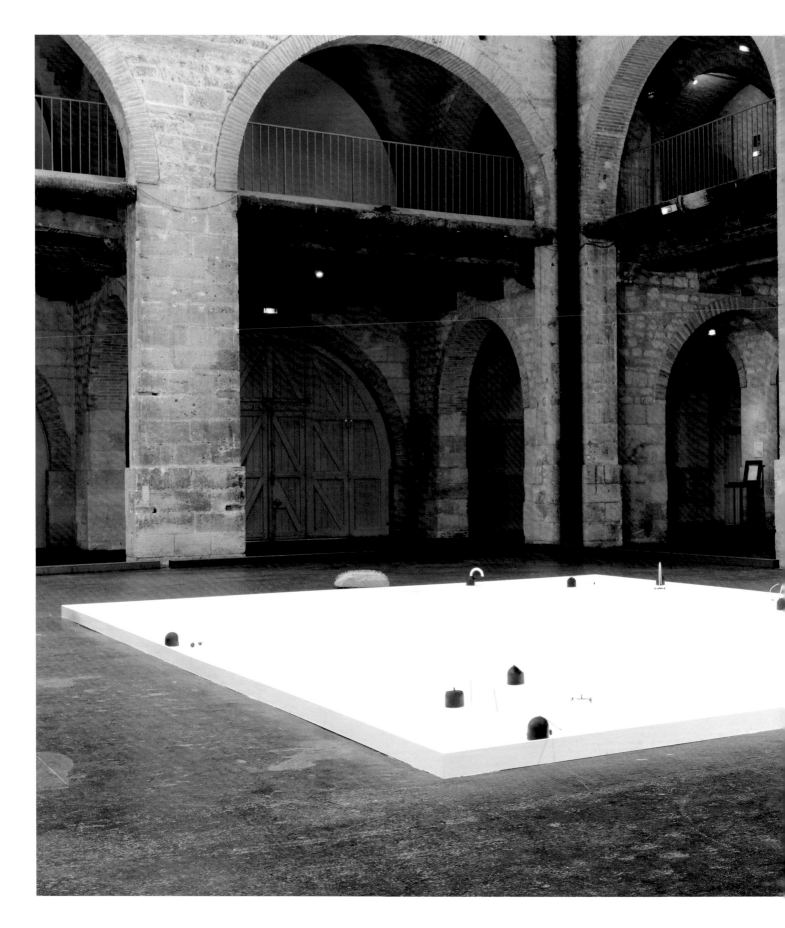

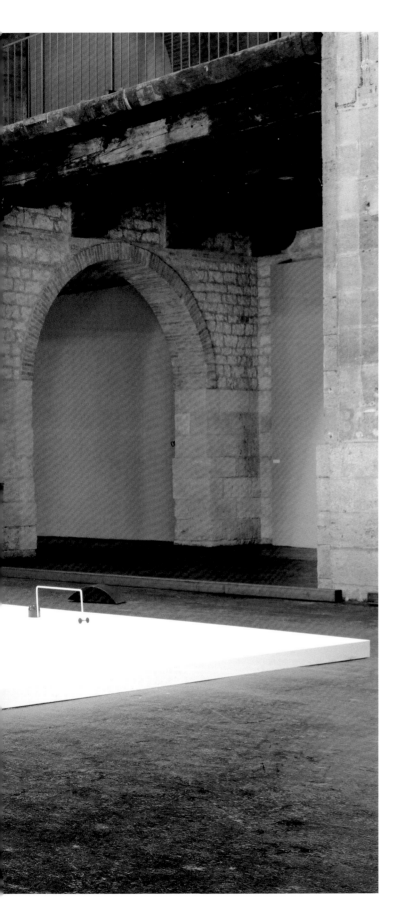

Floor Drawings in the exhibition *Robert Breer. Floats*
CAPC, Musée d'Art Contemporain, Bordeaux, 2010

Floordrawings

The *Floordrawings* and the *Variations* hold a special position among the Floats works. Both groups of works were created in 1970. Robert Breer showed his newly created group of ninety-three *Variations* in 1971 at the Bonino Gallery in New York. The small *Floats* are all variations on the same basic form: a cylinder, about 15 cm high, and rounded at the top. However, each of the individual ninety-three elements was given a special shape by the artist. There are some slightly leaning *Variations*, others are cut-through, grown together or have a sloped cut at the top. But the basic shape always remains recognisable. All *Variations* were exhibited on a large table in the Bonino Gallery, on which they moved slowly about and arranged themselves in ever-changing compositions. This was an ideal set-up for the *Floats,* which could move and spread themselves around more or less undisturbed.

The *Floordrawings* are constructed using the same basic elements as the *Variations* but they have extensions – a rectangular or wire framework, partly supported by small wheels. Here, the constant changing of the room can also be traced on the surface, through drawings: always new, but also only ever short-lived, continuously rearranged through the elements' constant movements.

The *Variations* and *Floordrawings* create the impression of acting independently, maybe even more so than the larger *Floats*. They 'live' on their surface and form groups, scatter and reassemble in a different corner of the table. All this happens almost imperceptibly, at a very slow speed, unhurried, undetectable at first glance. And yet every time we look the composition is different; the elements have regrouped. Therefore the viewer is tempted to attribute a free will to the small *Floats* and to perceive them as animated, spirited sculptures – as an autonomously acting swarm.

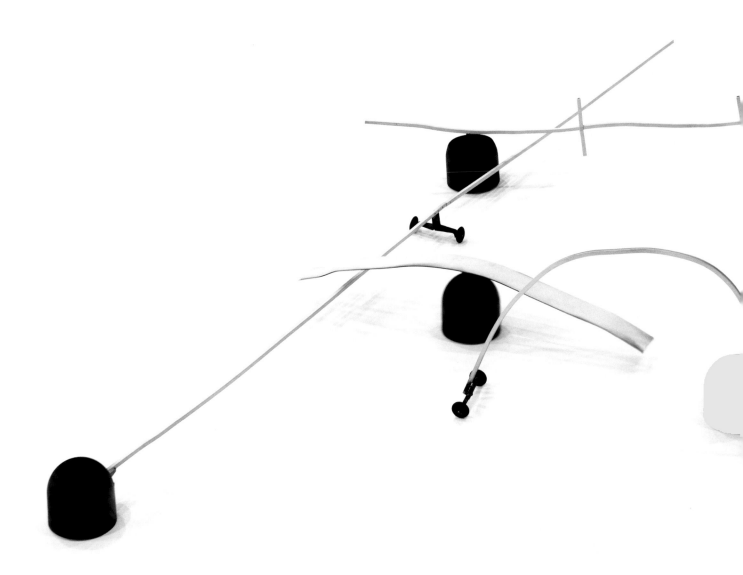

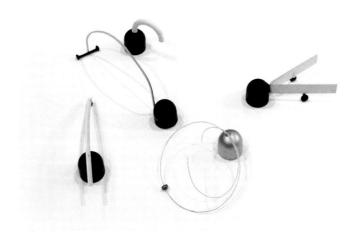

Floor Drawings, 1970
(detail, exhibition view)
Plastic, metal, acrylic paint, motor
Varying sizes

Page 131:
Floor Drawings in the exhibition
in the Michael Burger Gallery, Pittsburgh

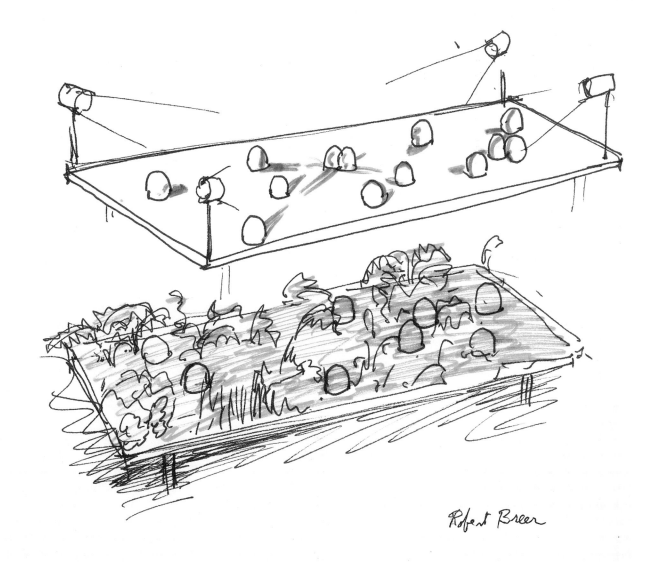

Untitled, n.d.
Technical drawing, coloured pencil on paper
21.5 x 28 cm

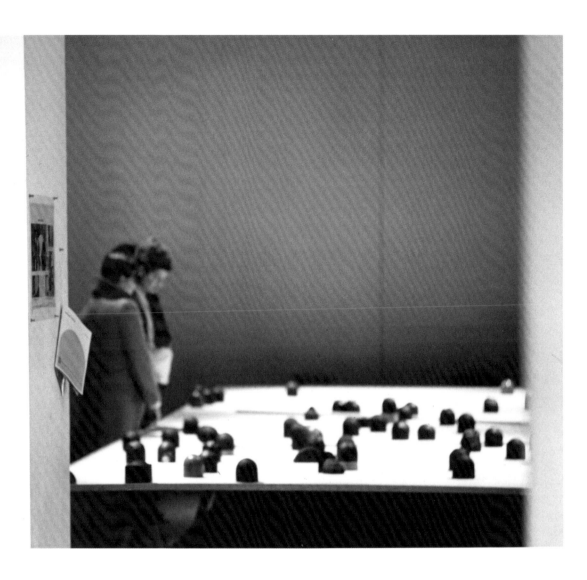

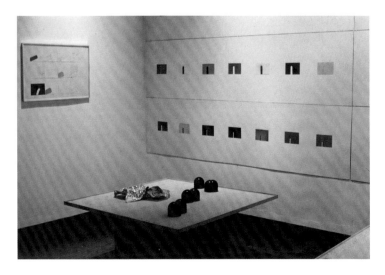

Variations and *drawings* for the film *70*
in the exhibition in the Bonino Gallery, New York, 1970

right:
Variations in the exhibition in the Bonino Gallery, New York, 1970

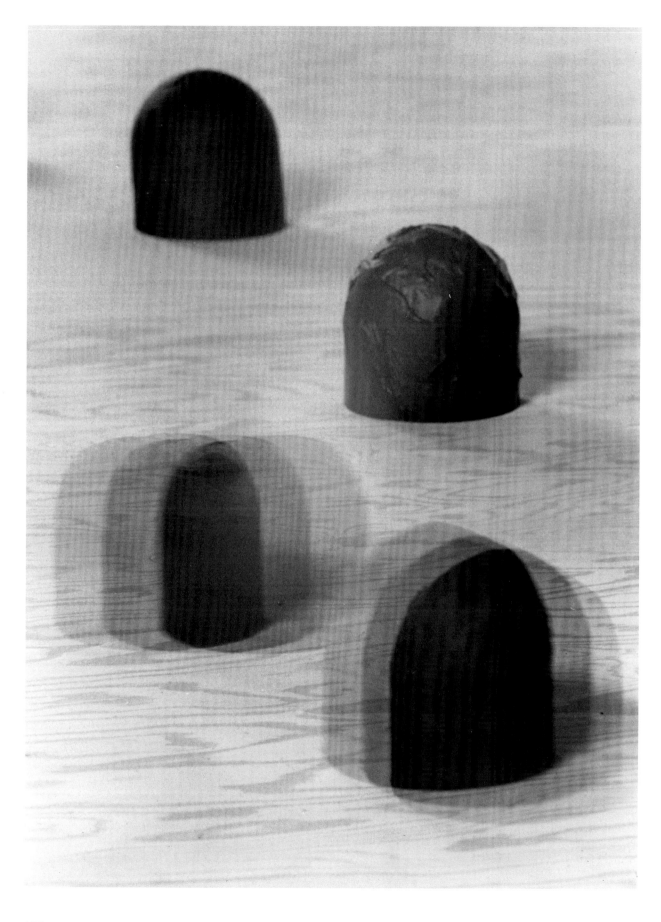

Floating Wall, 2009
Wood with honeycomb structures (light construction), steel substructure, motor
393.2 x 303.2 cm, 53.2 deep, H: 320 to 472 cm

Pages 138/139:
Wall and *Floats* in the exhibition *Robert Breer. Floats*
CAPC, Musée d'Art Contemporain, Bordeaux, 2010

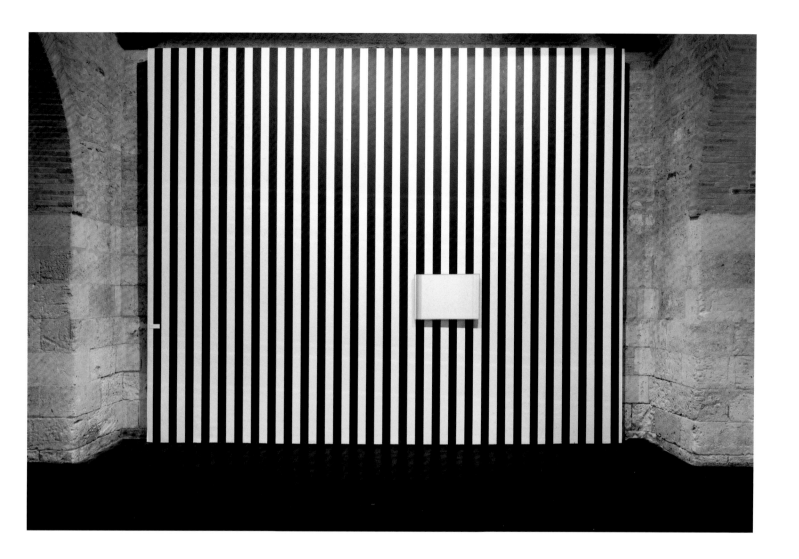

Tableau, 1965
Canvas on structure, motor
46.5 x 62 cm

Appendix

Exhibited Works

Untitled, 1949–1950 _____ Oil on canvas; 65 x 81 cm

Untitled, ca. 1950 _____ Oil on canvas; 164 x 133.5 cm

Composition aux trois lignes, ca. 1950 _____ Oil on canvas; 114.5 x 146 cm

Flip book, 1950 _____ Slidecraft, screws; 10.1 x 8.2 x 3 cm

Untitled, 1952 _____ Oil on canvas; 100 x 81 cm

Untitled, 1952 _____ Oil on canvas; 89 x 131 cm

Untitled, 1952 _____ Oil on canvas; 81 x 100 cm

Time Out, 1953 _____ Oil on canvas; 92 x 64 cm

Untitled, 1953 _____ Oil on canvas; 100 x 81 cm

Untitled, 1953 _____ Oil on canvas; 81 x 130.5 cm

Line Up, 1955 _____ Oil on canvas; 116 x 72 cm

Three Stage Elevator, 1955 _____ Oil on canvas; 91 x 60 cm

Tournant, 1955 _____ Oil on canvas; 99 x 81 cm

Sky Chief, 1955 _____ Oil on canvas; 80.5 x 100 cm

Lausanne, Musée cantonal des Beaux-Arts

Image par images, flip book, 1955 _____ Cardboard, paper; 12.6 x 9.2 x 1.1 cm

Edition for the exhibition *Le Mouvement*, Galerie Denise René. Paris, 1955

Image by images, flip book, ca. 1960 _____ Cardboard, screws; 12.6 x 7.6 x 2 cm

Untitled, flip book, 1960 _____ Cardboard sheets, watercolour, screws; 12.7 x 10.2 x 1.5 cm

Flip book, 1961 _____ Paper, screws; 5.1 x 6.3 x 1.3 cm

Untitled (Flower Pot), 1962 _____ Painted metal, metal rod, flower pot, motor; 60 x 14 x 14 cm

Homage to John Cage, 1963 _____ Folioscope, plastic, metal, acrylic paint; 112 x 25 cm

Folioscope, 1964 _____ Mutoscope, plastic, metal; 16.5 x 6.4 x 17 cm

Mural Flip Book, 1964 _____ Wood, metal, paper; 56 x 117 x 12.5 cm

Mutoscope, 1964 _____ Mutoscope, plastic, metal; 16.5 x 6.3 x 16 cm

Rotating Broom Stick, 1964 _____ Wood, metal, motor; 19 x 48 x 4 cm

Switz, 1965 _____ Polystyrene, motor; 12 x 13 x 60 cm

Zig, 1965 _____ Polystyrene, motor; 16 x 20 x 35 cm

gb agency, Paris

Tableau, 1965 _____ Canvas on structure, motor; 46.5 x 62 cm

Collection Clémence & Didier Krzentowski

Rug#5, 1965 _____ Black plastic, two motors; Dimensions variable

Collection E. Righi, Bologna, Italy

Rug, 1966 _____ Aluminium sheet, three motors; Dimensions variable

Collection Antoine de Galbert, Paris

Beam, 1966 _____ Motorised sculpture, painted styrofoam, motor, wheels; 15.5 x 25.5 x 15 cm

Collection of Charles J. Betlach II

Tank, 1966 _____ Painted metal, Styrofoam, motor, wheels; 14 x 24 x 48 cm

Private Collection, Paris

66, 1966 _____ 24 original 4 x 6 index card drawings from the film *66*; 93.5 x 74 cm

Collection of mima. Presented by The Art Fund under Art Fund International

Borne, 1967 _____ Polystyrene, motor; 142 x 18 x 18 cm

Column, 1967 _____ Aluminium, motor; 168 x 37 cm

Porcupine, 1967 _____ Foam, matchsticks, motor; 51 x 18 x 33 cm

Rug, 1968 _____ Gold foil sheet, two motors; Dimensions variable

Untitled, 1969 _____ Coloured pencil and felt-pen on paper; 21.6 x 32.9 cm

Untitled, 1969 _____ Coloured pencil and felt-pen on paper; 21.5 x 33 cm

Untitled, 1969 _____ Coloured pencil and felt-pen on paper; 21.5 x 33 cm

70, 1970	Forty-five original drawings on wooden panel from the film *70*; 61 x 244 cm
70, 1970	Forty-five original drawings on wooden panel from the film *70*; 61 x 244 cm
70, 1970	Seven original drawings on wooden panel from the film *70*; 61 x 244 cm
70, 1970	Seven original drawings on wooden panel from the film *70*; 61 x 244 cm
70, 1970	Seven original drawings on wooden panel from the film *70*; 61 x 244 cm
Floor Drawings, 1970	Plastic, metal, paint, motors
	62 x 23.5 x 9 cm; 47 x 28 x 10.5 cm; 192 x 11 x 9 cm; 60 x 11 x 9 cm;
	Collection Musée d'Art Moderne Grand-Duc Jean, Mudam Luxembourg
Floor Drawings, 1970 – 2001	Plastic, metal , paint, motors; Variable dimensions
	FNAC 02-244; Centre National des Arts Plastiques (France)
Variations, 1970	Two motorized sculptures, plastic, acrylic paint, motors; 12.7 x 7.6 cm
	Private Collection, Erlenbach, Switzerland
Variations, 1970	Plastic, acrylic, paint, motor; 15.5 x 18.5 cm (max)
Float, 1970–2004	Fiberglass on steel chassis, electric motor, car battery; 183 height x 180 diameter
	FRAC Franche-Comté, Besançon, France;
	Technical execution and motorisation: Didier Warin
Float, 1970–2011	Fiberglass on steel chassis, electric motor, car battery; 180 height, 180 diameter
Float, 1970–2011	Fiberglass on steel chassis, electric motor, car battery; 180 height, 180 diameter
Untitled, 1971	Coloured pencil and felt-pen on paper; 30.5 x 45.5 cm
Float, 1972	Polyester, paint, wood, motor; 50 x 100 cm
Float, 1972	Polyester, paint, wood, motor; 50 x 100 cm;
	Mildred Lane Kemper Art Museum, Washington University in St. Louis. University purchase, Bixby Fund, with funds from James W. Singer, Jr.; the Frederic Olsen Foundation; Benjamin Weiss; Bernard Drewes in memory of his father, Werner Drewes; Mrs. James W. Singer, Jr.; Constance Wittcoff; Harald Drewes in memory of his parents, Margaret and Werner Drewes; and Morton D. May, by exchange, 2011.
Float (Hammarskjold Plaza), 1972	Polyester, paint, wood, motor, wheels; 41.8 x 92.8 cm
	Fundación Almine y Bernard Ruiz-Picasso para el Arte
Untitled, 1972	Graphite on paper; 28 x 21.7 cm
Recreation, 1977	(film realised in 1957); 35 mm film, Kodachrome, framed under Plexiglass; 76.2 x 190.5 cm
3 D-Mutoscope, 1978–1980	Wood, paper, glass; 56 x 20.5 x 23 cm
	Collection Antoine de Galbert, Paris
Linear Mutoscope, 1993	Graphite on paper; 30 x 45.5 cm
Sponge, 2000	Plastic foam, motor; 15 x 62 x 65 cm
Sponge, 2000	Plastic foam, motor; 17 x 100 x 37 cm
Panorama 1, 2005	Collage and paintings on cardboard and wood; 40 x 700 x 20

Loaf, 2007	Painted polyester, motor; 80 x 60 x 100 cm
Slice, 2008	Painted styrofoam, motor; 19 x 18.5 x 21 x 10 cm
Silvercup, 2008	Painted styrofoam, motor; 20 x 20.5 x 14.5 cm
Floating Wall, 2009	Wood with honeycomb structures (light construction), steel substructure, motor
	393.2 x 303.2 cm, 53.2 deep, Height: 320 to 472 cm
	Technical execution and motorisation: Didier Warin

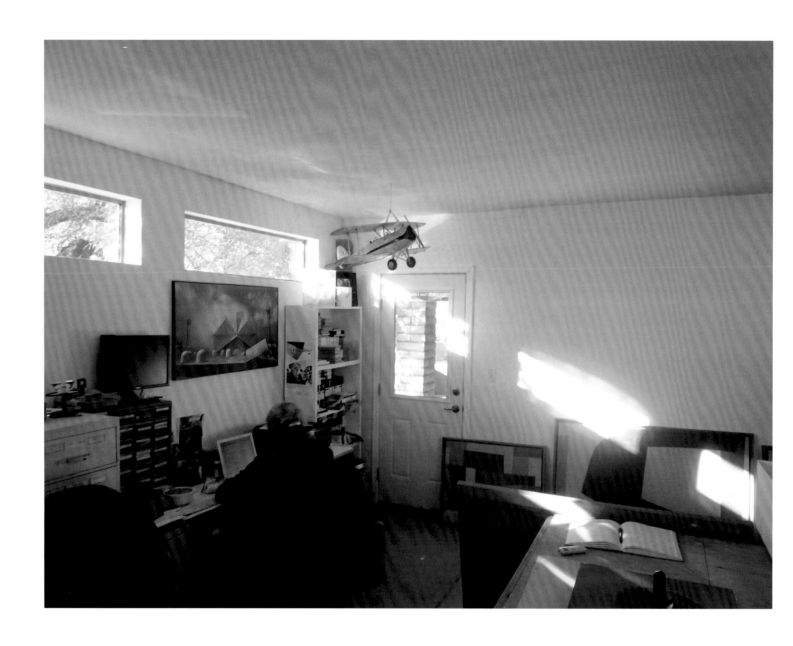

Robert Breer in his work room
in Tucson, Arizona, Summer 2010

Biography

For fifty years Robert Breer has eluded labels. His work in different media, including sculpture, painting, drawing and film, is characterized by a dialogue between each of these processes. Born in 1926 in Detroit, Michigan, he currently lives and works in Tucson, Arizona.

After gaining a BA in Art from Stanford University in 1949, Robert Breer began his career as a painter. In the same year he moved to Paris and joined the Galerie Denise René. He began to introduce elements into his painting that broke with the conventions of Neo-plasticism, developing a more sensual style with free floating lines. In an attempt to understand how he arrived at this point, he made a *flip book* of a small painting; this, the first of many, became the basis for *Form Phases,* his first film, in 1952. Since the beginning, Breer's films deny narrative structure; instead they are comprised of seeming sequences of photograms, drawings, collages, sound and photographs. Breer explores every possible interaction between colour, speed, and the appearance and disappearance of forms. He creates rapid rhythms, produces randomness out of unpredictable juxtapositions, and uses an irreverent tone.

In 1959 Breer gave up painting and began making mutoscopes and folioscopes, giving these modest objects (a precursor to his filmmaking) a new eligibility as serious sculpture. Back in America, he settled in New York and exhibited his first self-propelled moving sculptures. These geometric modules move at an almost imperceptible speed at ground level. The works test the thresholds of perception, challenging the limits of the definition of sculpture and its new relation to the exhibition space. Breer's 'floats' reveal an unstable and individual present that is part of a continual flow, putting the spectator at the centre of a changing world that is subjective and without rules. His collaboration with the Bonino Gallery in New York started in 1965. In 1968, along with the group *E.A.T. (Experiments in Art and Technology),* he initiated and participated in the Pepsi-Cola-Pavilion for the 1970 World Fair Exhibition in Osaka, Japan.

In 1971 his film style shifted from an abstract to a more eclectic mode, including the use of rotoscoping and filmed and photographed images. In 1973 he began teaching filmmaking at the Cooper Union. He remained in charge of this department until 2001.

In 1980 there was a major retrospective of Breer's work at the Whitney Museum of American Art, followed by others in both America and Europe. In 1981, he was commissioned for a large mural on the outside of the Film Forum in New York.

Breer is the recipient of many awards, including the Max Ernst Prize at the Oberhausen Film Festival in Germany in 1969, and more recently the Stan Brakhage Vision Award in Denver, Colorado, in 2005. In 2002 his film *Fuji* was registered in the permanent film collection of the Library of Congress, Washington, DC.

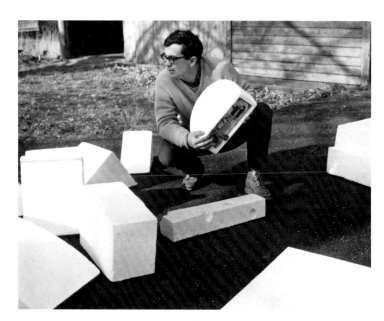

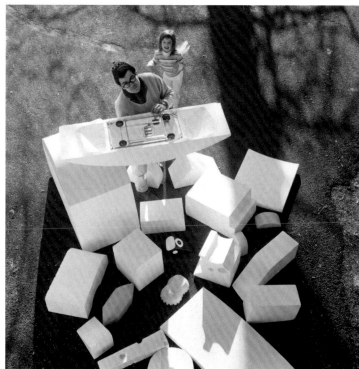

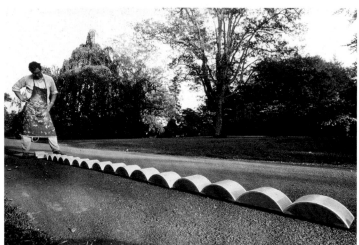

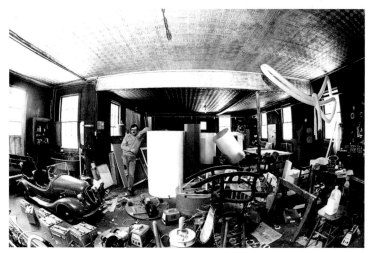

Robert Breer with some *Floats*, 1966

Robert Breer with *Self Propelled Aluminium Tanks*, 1967

Robert Breer with some *Floats*, 1966

Robert Breer in his studio, New York, 1976

Robert Breer in the gb agency, Paris 2003

Exhibition History: Solo Shows (selected)

2010 – *Robert Breer, Clouds*, gb agency, Paris
– *Robert Breer, Floats*, CAPC, Musée d'Art Contemporain, Bordeaux
– Screening of *Robert Breer*, during the exhibition *Nothing is Forever*, South London Gallery, London

2009 – Art Premiere, Art Basel, gb agency, Basel (with Mark Geffriaud)

2008 – Art Basel Miami Beach, Art Nova, gb agency, Miami
– Screening, California Institute of the Arts, Valencia, CA
– *Robert Breer: Filme*, Projects in Art & Theory, Cologne
– Screening, Harvard University, Massachusetts
– Screening, UCLA, Los Angeles
– *3 RADICALS, Robert Breer*, Tent Space, Rotterdam, curated by Edwin Carrel
– Screening of new 35 mm prints of Robert Breer films, Anthology Film Archive, New York

2007 – *Soirée spéciale Robert Breer*, during the exhibition *The Third Mind*, Palais de Tokyo, Paris
– Aurora Festival, Norwich, United Kingdom
– *Robert Breer*, FRAC Franche-Comté, Besançon

2006 – *Robert Breer: Films, Floats & Panoramas*, Musée-Château d'Annecy; Musée d'art Roger-Quilliot, Clermont-Ferrand
– Screenings, soirees following the conference, MAC/VAL – Musée d'Art Contemporain du Val-de-Marne, Vitry-sur-Seine

2005 – *Screens + Floats*, Filmmakers Galleries, Pittsburgh
– Screening, Stan Brakhage Vision Award, Denver
– *Float*, Lycée Jean-Pierre Timbaud in collaboration with the Centre d'Art Contemporain de Brétigny, Brétigny

2004 – *Robert Breer*, gb agency, Paris
– *Carte Blanche à Robert Breer*, Scratch Projections, Centre Wallonie Bruxelles, Paris

Invitation card to the exhibition *Robert Breer*
gb agency, Paris 2004

2001 – *E-motion*, retrospective of the films by Robert Breer, Musée National d'Art Moderne, Centre Georges Pompidou, Paris
– *Robert Breer*, gb agency, Paris

2000 – *Float*, Museum of Modern Art, New York
– Screening, Walker Art Center, Minneapolis
– *Robert Breer*, Staff USA/AC Project Room, New York

1999 – *Robert Breer*, Staff USA/AC Project Room, New York

1998 – *De Klein à Warhol*, Musée d'Art Moderne et d'Art Contemporain, Nice
– Screening, Université de Toulouse II – Le Mirail, Toulouse
– Screening, Österreichisches Filmmuseum, Vienna
– Screening, Université de Paris, Paris
– Screening, Les Archives du film expérimental, Avignon
– Screening, Musée de la Vieille Charité, Marseille
– Screening, Mires, Nantes
– Screening, AMAMCS (Les Amis du Musée d'Art Moderne et Contemporain), Strasbourg
– Screening, Aarn, Colmar

1997 – Screening, Université Paris-Sorbonne (Paris IV), Paris
– Screening, Städelschule, Frankfurt am Main
– Screening, Le Havre
– *Zoobizarra*, Bordeaux
– Screening, Chicago Filmmakers, Chicago

1996 – Screening in the exhibition room *L'art du mouvement: collection cinématographique du Musée national d'art moderne, 1919–1996*, Musée National d'Art Moderne, Centre Georges Pompidou, Paris
– Screening, Projections Scratch, L'entrepôt, Paris
– Screening, Universität Zürich, Zurich

1995 – Screening, Clark University, Worcester
– Screening, The Museum School, Boston
– Screening, Rhode Island School of Design/Carpenter Center, Brown University, Providence

1993 – Screening, Exploratorium, San Francisco
– Screening, Cinematheque, San Francisco
– Screening, Innis Film Society, Toronto
– Screening, Bard College, New York

1992 – *Le Film d'Animation Expérimental aux U.S.A: Hommage à Robert Breer*, l'Animathèque, Cinémathèque Française, Palais de Tokyo, Paris
– Screening, University of Rhode Island, Kingston

1990 – *Robert Breer. A Painter in Paris 1949–1959*, Galerie 1900–2000, Paris
– Screening, Carnegie Mellon, Pittsburgh
– Screening, Boston College/Boston Museum School, Boston
– Screening, University of Rhode Island, Kingston
– Screening, Boston Film Video Foundation, Boston
– Screening, Berkeley Film Archives, Berkeley

1989 – *Suny*, Binghampton, Upstate New York Tour
1988 – *Robert Breer*, The Lux Cinema, London
– Screening, Walker Art Center, Minneapolis
1987 – Screening, Pennsylvania University, Philadelphia
– Screening, Carnegie Mellon Boston College, Boston
– Screening, Boston Museum School, Boston
– Screening, University of Rhode Island, Kingston
– Screening, Boston Film Video Foundation, Boston
– Screening, Berkeley Film Archives, Berkeley
– Screening, Visual Studies Workshop, Rochester, New York
1986 – Screening, Chicago Art Institute, Chicago
– Screening, Ithaca College, New York
1985 – *Spectracolor Screen*, Times Square, New York
1984 – Screening, Hampshire College, Massachusetts/New City
Coop, Nebraska
– Screening, Sheldon Film Theater/University of Nebraska,
Nebraska

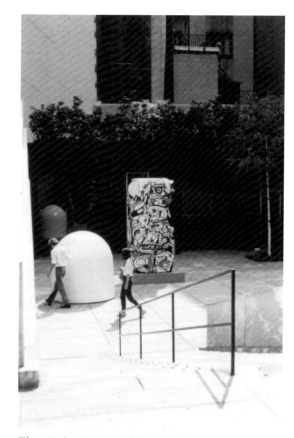

Float in the Museum of Modern Art,
New York, 1970

1983 – *Robert Breer, Five and Dime Animator, a Complete
Retrospective in Context*, ICA, Institute of Contemporary
Art, London, Cambridge Animation Festival
– Screening, British Film Institute, London
– Screening, Museum of the Moving Image, London
1982 – Screening, Carnegie Museum of Art, Pittsburgh
– Screening, Museum of Modern Art, New York
1981 – *Mural*, Film Forum, New York
– *Robert Breer*, Millennium Film Workshop, New York
– Screening, Academy of Motion Picture Arts and Sciences,
Los Angeles
1980 – *Retrospective: Films, Drawings, Mutoscopes*, Whitney
Museum of American Art, New York
1978 – Screening, Cinema Brera Milano, Milan
– Screening, Österreichisches Filmmuseum, Vienna
1977 – *Robert Breer: Films and Installation*, Whitney Museum
of American Art, New York
1975 – *Cineprobe*, Museum of Modern Art, New York
– Albright-Knox Art Gallery, Buffalo, New York
– Yale University, New Haven
1974 – *Sculpture*, IBM Plaza, Pittsburgh
– Screening, Three Rivers Arts Festival, Pittsburgh
– Screening, Film Forum, New York
– *Films by Robert Breer, Painter, Sculptor, Filmmaker*,
Hirshhorn Museum and Sculpture Garden Film Program,
Washington
1973 – *Sculpture*, Hammarskjold Plaza, New York
1972 – *Robert Breer*, J.L. Hudson Gallery, Detroit
1970 – *Osaka I*, Sculpture Garden, Museum of Modern Art,
New York
– *93 Floats*, Bonino Gallery, New York
– *Cineprobe*, Museum of Modern Art, New York
1968 – Bonino Gallery, New York
– *Floats*, Galerie Ricke, Cologne
1967 – *More Floats*, Bonino Gallery, New York
1966 – *Floats*, Bonino Gallery, New York
1965 – *Constructions and Films*, Bonino Gallery, New York
1964 – *Hard Center*, Thibaut Gallery, New York
1963 – *Robert Breer*, Dwan Gallery, Los Angeles
1962 – *Retrospective Film Showing*, Bleeker Cinema,
New York
1961 – *Film Retrospective*, Charles Cinema, New York
– *Robert Breer*, Mayer Gallery, New York
1960 – *Robert Breer's Films*, Mayer Gallery, New York
1956 – *Robert Breer*, American Center for Students and Artists
in Paris, Paris
1955 – *Robert Breer: peintures et dessins*, Galerie Aujourd'hui,
Palais des Beaux-Arts, Brussels

Exhibition History: Group Shows (selected)

2011 – *Bild für Bild – Film und zeitgenössische Kunst aus der Sammlung des Centre Pompidou*, Museum Ostwall in cooperation with the Centre Georges Pompidou Paris, Dortmunder U, Dortmund

2010 – *Art Fund International/Drawing in Progress*, mima – Middlesbrough Institute of Modern Art, Middlesbrough
– *A Shot in the Dark*, Walker Art Center, Minneapolis
– *A Handshake. Danish and French avant-garde 1945–1970*, Fyns Kunstmuseum, Odense
– *Sensorialités excentriques*, Musée départemental d'Art Contemporain, Rochechouart
– Screening, Musée des Arts Contemporains, Site du Grand Hornu, Hornu
– *Made in Tucson/Born in Tucson/Live in Tucson, Part I*, MOCA – Museum of Contemporary Art, Tucson
– *Greater New York*, *The Baghdad batteries*, MOMA P.S.1 Contemporary Art Center, New York
– *The Evryali Score*, David Zwirner Gallery, New York
– *New Realisms: 1957–1962. Object Strategies Between Readymade and Spectacle*, Museo Nacional Centro de Arte Reina Sofía, Madrid
– *The Living Currency/La Monnaie Vivante*, Teatr Dramatyczny, Muzeum Sztuki Nowoczesnej, Warsaw
– *The Living Currency/La Monnaie Vivante*, Hebbel Am Ufer, 6th Berlin Biennale for Contemporary Art, Berlin
– *The Dissolve*, SITE Santa Fe Biennial 2010, Santa Fe
– *In the Face of Spatial Grandeur*, Circuit, Lausanne
– *Le Mouvement. Vom Kino zur Kinetik*, Museum Tinguely, Basel
– *Déjà vu*, Université Paris 1 Panthéon-Sorbonne, Paris
– Holland Animation Film Festival, Utrecht

2009 – *Joyous Machines: Michael Landy and Jean Tinguely*, Tate Liverpool, Liverpool
– *Réversibilité, Un théâtre de la dé-création*, CAC – Centre d'art contemporain, Bretigny
– *Les belles images – Première hypothèse*, ENSA – École nationale supérieure d'art, Bourges
– *Silent Pictures Explores the Nonverbal Power of Comics*, Cuny Graduate Center, New York
– *90*, FRAC Franche-Comté, Saline Royale d'Arc-et-Senans
– *Ultramodernes paysages*, Musée d'Art Roger Quilliot, Clermont-Ferrand
– *The Death of the Audience*, Secession, Vienna
– *First Stop on the Super Highway*, Nam June Paik Art Center, Seoul
– Screening, École nationale supérieure des beaux-arts, Paris
– *A Mancha Humana / The Human Stain*, CGAC – Centro Galego de Arte Contemporánea, Santiago de Compostela
– *Chhttt… Le merveilleux dans l'art contemporain* (2ème volet), CRAC Alsace – Centre Rhénan d'Art Contemporain, Altkirch

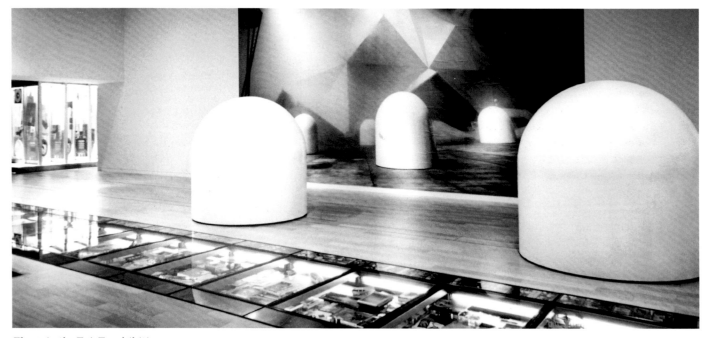

Floats in the E.A.T. exhibition
Inter Communication Center, Tokyo, 2003

– Screening, *Umberto Eco, l'œuvre ouverte et après*,
 Auditorium du Louvre, Paris
2008 – *Les Feuilles*, Module, Palais de Tokyo, Paris
 – *Les Feuilles*, Super, Paris
 – *Jean Tinguely – Eine Retrospektive*, KunstHaus Wien,
 Vienna
 – Screening during the exhibition *Traces du sacré*, Musée
 National d'Art Moderne, Centre Georges Pompidou, Paris
 – Cinematic Panorama, gb agency, Paris
 – *The Third Mind. Carte blanche à Ugo Rondinone*, Palais de
 Tokyo, Paris
 – *E.A.T. REVISITED*, Stevens Institute of Technology Babbio
 Center, Hoboken, New Jersey
 – Collections new presentation, Musée National d'Art
 Moderne, Centre Georges Pompidou, Paris
 – *Drawing on Film*, The Drawing Center, Rose Art Museum,
 Waltham, MA
 – *37th International Film Festival of Rotterdam*, Rotterdam
2007 – *Du machinique et du vivant*, La Réserve, Pacy-sur-Eure
 – *Extremes and In-Betweens*, Dorsky Gallery,
 Long Island City
 – *Playback*, Musée d'Art Moderne de la Ville de Paris/ARC,
 Paris
 – *Poor Thing*, Kunsthalle Basel
 – *Re-trait*, Fondation d'entreprise Ricard, Paris
 – *Raw Among the Ruins*, MARRES – Centre for Contemporary
 Culture, Maastricht
 – *Momentary Momentum: Animated Drawings*, Parasol Unit,
 London
 – *Time Flies*, gb agency, Paris
2006 – *Le mouvement des images*, Musée National d'Art Moderne,
 Centre Georges Pompidou, Paris
 – *Art multiple*, Espace de l'Art Concret, Mouans-Sartoux
 – Screening, Le Cinématographe, Nantes
2005 – *Motion at Sketch*, Sketch, London
 – *Perspectives*, Fiac, gb agency, Paris
 – *Petites Compositions entre Amis, Séquence 2*,
 gb agency, Paris
 – *Histoire de points de vue*, Le Lazaret Ollandini, Ajaccio
 – *L'œil Moteur, Art Optique et Cinétique, 1950–1975*,
 Musée d'Art Moderne et Contemporain, Strasbourg
 – *Vorticanti*, Galleria Maze, Turin
 – *Beyond Geometry: Experiments in Form, 1940–70*,
 Museum of Contemporary Art, Miami
 – *Repetitions*, Maya Stendhal Gallery, New York
 – *Le cinéma experimental japonais: Vues d'ici. Année des
 échanges entre l'Union Européenne et le Japon*, Faux
 Mouvement – Centre d'Art Contemporain, Metz

– Public conference, Carnegie Museum of Art, Pittsburgh
– Screening and conference, Massachusetts Institute of
 Technology, Boston
– *Daumenkino. The Flip Book Show*, Kunsthalle Düsseldorf
2004 – *35h*, Les Laboratoires, Aubervilliers
 – *Carnegie International*, The Carnegie Museum of Art,
 Pittsburgh
 – *Projets spéciaux*, Parvis Fiac, gb agency, Paris
 – *Beyond Geometry: Experiments in Form, 1940–1970*,
 County Museum, Los Angeles
 – *Genesis Sculpture, Expérience #1*, Domaine Pommery, Reims
 – *E.A.T. Exposition*, Norrköping Film Festival, Sweden
 – Ottawa International Animation Festival, Canada
 – 50th Flaherty Film Seminar, Vassar College, NY
 – London Film Festival, London
 – *Mouvement de Fonds, acquisitions 2002 of Fonds National
 d'Art Contemporain*, Centre de la Vieille Charité, MAC –
 Galeries Contemporaines des Musées de Marseille
 – *The Pontus Hultén Collection*, Moderna Museet, Stockholm
 – *What Goes Up?*, Film Festival, San Francisco
 – *What Goes Up?*, Jeonju International Film Festival, Seoul
 – *What Goes Up?*, 21° Torino Film Festival, Torino
 – Festival *Progetto Animation 2*, Rome
2003 – *Links*, gb agency, Paris
 – New York Film Festival, New York
 – *E.A.T.*, InterCommunication Center, Tokyo
 – *Seeing, Watching, Filming*, screenings *A Man and his Dog
 Out For Air* and *What Goes Up?*, 33rd International Film
 Festival, Rotterdam
 – Screening, New Zealand Film Festival
 – *A Happening Place*, The Gershman Y Galleries, YMHA,
 Philadelphia
 – *Mouvements de Fonds*, MAC – Galeries Contemporaines
 des Musées de Marseille
2002 – *Cinéma visionnaire*, Forum des Images, Paris
 – *What (is) Cinema, other than film?*, TENT Centrum
 Beeldende Kunst, Rotterdam
 – *Moderna Museet c/o Magasin 3*, Magasin 3, Konsthall,
 Stockholm
 – *Inside the Sixties: GP 1.2.3*, Musée Cantonal des Beaux-Arts,
 Lausanne
 – *Nouvelles acquisitions*, Musée National d'Art Moderne,
 Centre Georges Pompidou, Paris
 – *Liste*, gb agency, Basel
 – *Dessins XXL*, screening, Le Lieu Unique, Nantes
 – *French Connection, acquisitions du Fonds National
 d'Art Contemporain*, Mamco – Musée d'art moderne et
 contemporain, Geneva

– *Kinetic Moment*, Carnegie Mellon, Pittsburgh
– *Film Selection*, Anthology Film Archives, New York
– Rivertown Film Society, Nyack
– Filmstudio 80, Il cinema visionario, Rome
2001 – Screening, London Film Festival, London
– *Œuvres sur papier, cinquante années de création*, galerie Denise René, Paris
– Screening, Internationale Kurzfilmtage Oberhausen
– *Animation expérimentale*, Scratch Projections, Paris
– *Hors Jeu sur Batofar*, installations and screenings, Batofar, Paris
– *Hors-Jeu*, gb agency, Paris
– *Animations*, PS1, Contemporary Art Center, New York
– *Les années Pop*, Musée National d'Art Moderne, Centre Georges Pompidou, Paris
200 – *Useless Science*, Museum of Modern Art, New York
1999 – *Kunst im Aufbruch – Abstraktion zwischen 1945 und 1959*, Wilhelm-Hack-Museum Ludwigshafen am Rhein
1998 – *Oops*, Le Magasin, Centre National d'Art Contemporain, Grenoble/L'Elac, Espace Lausannois d'Art Contemporain, Lausanne
– Screening, Deutsches Filmmuseum, Frankfurt am Main
1997 – *The Maximal Sixties*, Museum of Modern Art, New York
1995 – *Beat Culture and the New America 1950–1965*, Whitney Museum of American Art, New York
1994 – *Set in Motion*, Lincoln Center, New York
1993 – *American Films in Moscow*, Moscow
1992 – *Moving Pictures: Films by Photographers*, Ontario Gallery of Art, Toronto
1991 – *Beyond Cartooning*, Walker Art Center, Minneapolis
1990 – Visual Studies Workshop, Rochester, NY
– *Nouvelles acquisitions*, Archives du film expérimental, Avignon
1987 – *The Animation Festival*, Bristol
– *Made in USA*, University Art Museum, Berkeley, CA
1986 – *New American Animation*, Film Forum, New York
– *The Arts on Britain's Channel 4*, The Museum of Broadcasting, New York
1985 – *Whitney Biennial*, Whitney Museum of American Art, New York
1984 – Telluride Film Festival, Colorado
1983 – *Whitney Biennial*, Whitney Museum of American Art, New York
1981 – *Whitney Biennial*, Whitney Museum of American Art, New York
1979 – Screening, Museum of Modern Art, New York
– *The Film Tradition and Those Who Broke It*, Macalaster College, St Paul, Minnesota

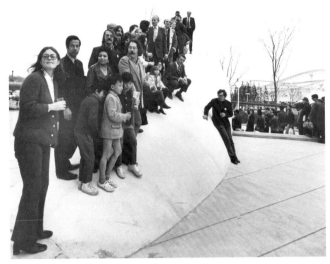

Robert Breer and the team
at the Pepsi-Cola-Pavilion, Osaka 1970

– *Whitney Biennial*, Whitney Museum of American Art, New York
1977 – *Whitney Biennial*, Whitney Museum of American Art, New York
– *Paris – New York*, Musée National d'Art Moderne, Centre Georges Pompidou, Paris
– *Film As Art*, Educational Film Library Association, New York
1976 – *Une Histoire du Cinéma*, Musée National d'Art Moderne, Centre Georges Pompidou, Paris
1974 – *New Forms in Film*, Montreux
– New York Film Festival, New York City
1973 – *Options and Alternatives*, Yale Art Gallery, New Haven, Connecticut
– *Whitney Biennial*, Whitney Museum of American Art, New York
– New York Film Festival, New York City
1971 – *Whitney Biennial*, Whitney Museum of American Art, New York
– *Kid Stuff?*, Albright-Knox Art Gallery, Buffalo
– *VIIème Biennale des Jeunes*, Musée d'Art Moderne de la Ville de Paris, Paris
1970 – *The Artist's Viewpoint*, Jewish Museum, New York City
– Galerie Ricke, Kassel
– *Expo '70*, curated by Experiments in Art and Technology, Pepsi-Cola Pavilion, World Exhibition, Osaka

– *Plans and Projects as Art*, Kunsthalle Bern
– *Kinetics*, Hayward Gallery, London
1969 – *New Media*, Museum of Modern Art, New York
– Galerie Ricke, Kassel
– *Impression des USA*, Galerie Françoise Mayer, Brussels
– *Nine Evenings*, 23rd Street Armory, New York City
– *Electric Art*, UCLA Art Galleries; Phoenix Art Museum, Phoenix
1968 – *The Machine as seen at the End of the Mechanical Age*, Museum of Modern Art, New York
– *Neue Kunst USA/Barock-Minima*, Modern Art Museum, Munich
– *Highlights of 67, 68 Season*, Aldrich Museum of Contemporary Art, Ridgefield, Connecticut
1967 – *Artists as Film Maker*, Jewish Museum, New York
– *Nuove tecniche d'immagine*, Biennale San Marino
– *Kinetic Art*, University of Hawaii, Honolulu
– *Exchange show*, Museum of Modern Art, New York; Tokyo Museum of Modern Art, Tokyo
– Knokke Experimental Film Festival, Knokke
– *Museum of Merchandise*, Arts Council, Philadelphia, Pennsylvania
1966 – *Kinetic Art*, University Art Museum, Berkeley, CA
– *Now*, Festival, Washington
– *Projected Art*, Finch College Museum, New York
– *2ème Salon International des Galeries-Pilotes*, Bonino Gallery, Musée Cantonal des Beaux-Arts, Lausanne
– *Special Event*, New York Film Festival, New York
– *Kinetic and Programmed Art*, Rhode Island School of Design, Providence
– *Art Turned On*, Institute of Contemporary Art, Boston
1965 – *Fist Fight*, New York Film Festival and London Film Festival
– *Art Turned On*, Institute of Contemporary Art, Boston
– *Inner and Outer Space*, Moderna Museet, Stockholm
– *The Independent Film*, Museum of Modern Art, New York
– *Optical and Kinetic Art*, Ohio University
1964 – *For Eyes and Ears*, Cordier & Ekstrom Inc. Gallery, New York
– Screening of *Fist Fight* as opening piece of Karlheinz Stockhausen's *Originale*, Judson Hall, New York
– *American Avant-Garde Film Series*, Gallery of Modern Art, New York
– *Breathing*, film selection, New York Film Festival, Lincoln Center, New York
1963 – *Popular Image*, Washington Gallery of Modern Art, Washington
– *Independent Film Makers*, Museum of Modern Art, New York

1962 – *Best New American Independent Films*, Cinema 16, Carnegie Hall Cinema, New York City
– *Art 1963 – A New Vocabulary*, Arts Council, Philadelphia, Pennsylvania
1961 – *International Exposition of Art in Motion*, Amsterdam, Stockholm, Copenhagen
1959 – *Movement*, Hessenhuis, Antwerp
– Galerie Iris Clert, Paris
– Experimentalfilmfestival (Compétition Internationale du Film Expérimental), Foire de Bruxelles, Brussels
1958 – *Salon de Mai*, Grand Palais, Paris
– *10 American Painters in Europe*, University of Wisconsin Art Education Gallery, Madison
– *Avant Garde Film Festival*, Moderna Museet, Stockholm
1957 – *Form + Experiment: An Exhibition of Non-Figurative Art*, New Vision Centre Gallery, London
1955 – *Le Mouvement*, Galerie Denise René, Paris
– Galerie Samlaren, Stockholm
– *Salon des Réalités Nouvelles*, Paris
– *VIII Festival International de Film Amateur*, Cannes
1954 – *Baertling, Bitran, Breer*, Galerie Denise René, Paris
1953 – *Denise René présente: Arp, Baertling, Battistini, Bloc, Bozzolini, Breer, Delaunay, Dewasne, Deyrolle, Dias, Domela, Gonzalez, Esteve, Gilioli, Istrati, Herbin, Jacobsen, Le Corbusier, Leger, Magnelli, Mortensen, Navarro, Poliakoff, Raymond, Schnabel, Schneider, Stahly, Vasarely*, Galerie Denise René, Paris
– *Salon des Réalités Nouvelles*, Paris
1952 – *7 – Breer, Chesnay, Degottex, Dimitrienko, Gadegaard, Youngerman, Zimmerman*, Galerie Denise René, Paris
– *Salon des Réalités Nouvelles*, Paris

Untitled, n.d.
Drawing on paper
30 x 43.6 cm

Filmography

- *Form Phases I*, 1952, 16 mm, 2 min, black and white, silent
- *Form Phases II*, 1953, 16 mm, 3.5 min, Kodachrome, silent
- *Form Phases III*, 1953, 16 mm, 3.5 min, Kodachrome, silent
- *Form Phases IV*, 1954, 16 mm, 3.5 min, Kodachrome, silent
- *Image by Images I*, 1954, 16 mm, looped film, Kodachrome, silent
- *Un Miracle*, 1954, 16 mm, 30 min, Kodachrome, silent
- *Image by Images II*, 1955, 16 mm, 3 min, black and white, silent
- *Image by Images III*, 1955, 16 mm, 3 min, black and white, silent
- *Image by Images IV*, 1955, 16 mm, 3 min, Kodachrome, silent
- *Motion Pictures*, 1956, 16 mm, 3 min, Kodachrome, sound
- *Cats*, 1956, 16 mm, 1.5 min, Kodachrome, sound by Frances Breer
- *Recreation I*, 1956–57, 16 mm, 2 min, Kodachrome, sound by Noël Burch
- *Recreation II*, 1956–57, 16 mm, 1.5 min, Kodachrome, silent
- *Jamestown Baloos*, 1957, 16 mm, 6 min, colour, black and white, optic sound
- *A Man and His Dog Out for Air*, 1957, 16 mm, 3 min, black and white, optic sound
- *Par Avion**, 1958, 16 mm, 2.5 min, colour, silent
- *Cassis Colank**
- *Eyewash*, 1958–59, 16 mm, 6 min, colour, title of the soundtrack: *Earwash*
- *Homage to Jean Tinguely's 'Homage to New York'*, 1960, 16 mm, 10 min, black and white, optic sound
- *Inner and Outer Space*, 1960, 16 mm, 4 min, colour, sound

- *Blazes*, 1961, 16 mm, 3 min, colour, optic sound
- *Horse Over Tea Kettle*, 1962, 16 mm, 6 min, colour, sound
- *Pat's Birthday*, 1962, 16 mm, 16 min, black and white, sound
- *Breathing*, 1963, 16 mm, 6 min, black and white, sound
- *Fist Fight*, 1964, 16 mm, 11 min, colour, sound
- *66*, 1966, 16 mm, 5 min, colour, sound
- *69*, 1968, 16 mm, 5 min, colour, optic sound
- *PBL #2*, 1968, 16 mm, 1 min, colour, sound
- *70*, 1970, 16 mm, 5 min, colour, optic sound
- *Gulls and Buoys*, 1972, 16 mm, 6 min, colour, sound
- *Fuji*, 1974, 16 mm, 10 min, colour, sound
- *Rubber Cement*, 1975, 16 mm, 10 min, colour, sound
- *77*, 1977, 16 mm, 10 min, colour, optic sound
- *LMNO*, 1978, 16 mm, 10 min, colour, optic sound
- *T.Z.*, 1979, 16 mm, 8.5 min, colour, optic sound
- *Swiss Army Knife with Rats and Pigeons*, 1980, 16 mm, 6 min, colour, optic sound
- *Trial Balloons*, 1982, 16 mm, 6 min, colour, optic sound
- *Bang!*, 1986, 16 mm, 8 min, colour, optic sound
- *A Frog on the Swing*, 1989, 16 mm, 5 min, colour, optic sound
- *Sparkill Ave!*, 1992, 16 mm, 5 min, colour, optic sound
- *Time Flies*, 1997, 16 mm, 5 min, colour, optic sound
- *ATOZ*, 2000, 16 mm, 5 min, colour, sound
- *What Goes Up?*, 2003, 16 mm, 5 min, colour, sound track: Jacob Burkhardt

Collaborations

- *Le Mouvement*, Robert Breer and Pontus Hultén, 1956, beta SP, 15 min. Film about the exhibition *Le Mouvement* at Galerie Denise René
- *Chutes de pierres, danger de mort*, Michel Fano, 1958, 16 mm, 17 min, black and white, sound. Assistant: Noel Burch. Montage: Yannick Bellon. Music: André Hodeir
- *Linoleum*, performance by Robert Rauschenberg (film by Ed Kelly), 1966, 16 mm, 13 min, black and white, sound
- *For Life, Against the War*, 1967, 16 mm, 75 min, colour, black and white, sound

Commissioned Films

- *Trailer*, 1959, 1 min, black and white, silent
- *Brinkley's Journal**, 1961–1962, 15 min, colour, sound Commissioned by Huntley Brinkley for the exhibition *Rörelse I Konsten* by Pontus Hultén in Stockholm, Sweden.
- *PBL2** and *PBL3**, 1968, 5 min, colour, no sound Commissioned by PBL Television.
- *David Bowie*, by Don Alan Pennebaker, ca. 1970, 3 min Part of the documentary
- *Elevator et What*, 1971, 1 min. each, colour, sound. Commissioned by CTW Television
- *Blue Monday Manual Video*, by Michael Shamberg, 4.5 min video clip beta Pal, for the band New Order.

Films about Robert Breer

- *Frames of Mind*, dir. Ann Woodward, camera Keiko Tsuno, 1979, 30 min, beta PAL
- *The 'Five and Dime' Animator*, 1984, 48 min, dir. Keith Griffiths, conceived by David Curtis and Simon Field
- *Robert Breer at Home*, by Jennifer L. Burford, 1992, 16 mm, 7 min, black and white and colour
- *Nine Portraits*, Pip Chodorov, 2004, 10 min, ARTE TV

* films out of screenings

Bibliography

2011 – Bénédicte Ramade, 'Robert Breer – Petit, mais costaud',
 in: *L'œil*, vol. 631
– Laura Hoptman, 'Looking back / Looking forward',
 in: *Frieze Magazine*, vol. 136
– Rozenn Canevet, 'La Grâce de la nonchalance, Robert
 Breer, sculptures flottantes', in: *02*, vol. 57
2010 – Bernard Marcelis, 'Robert Breer', in: *Art Press*, vol. 375,
 2010
– *Bild für Bild – Film und zeitgenössische Kunst*,
 ed. Kurt Wettengl, Museum Ostwall in cooperation with
 Centre Pompidou, Museum Ostwall Dortmund,
 18 December–25 April 2011, Dortmund 2010 (cat.)
– Michelle Kuo, 'Everything Goes. An interview with Robert
 Breer', in: *Artforum*, November 2010, pp. 214–221
– *Le Mouvement. Vom Kino zur Kinetik*, Museum Tinguely,
 Basel, 10 February–16 May 2010, Heidelberg 2010 (cat.)
– *New Realisms: 1957–1962. Object Strategies Between
 Readymade and Spectacle*, ed. Julia Robinson.
 Museo Nacional Centro de Arte Reina Sofía, Madrid,
 15 June–4 October 2010, Cambridge, Mass. 2010 (cat.)
– Simone Menegoi, 'Engineering Uncertainty', in:
 Kaléidoscope, vol. 5, February–March 2010, pp. 42–47
– *Conversation entre Robert Breer et Mark Geffriaud*,
 publication of the gb agency for Art 40 Basel, 2010
2009 – *The First Stop on the Super Highway*, ed. Tobias Berger.
 Nam June Paik Art Center, Seoul, 7 March–16 May 2009
 (cat.)
– *Joyous Machines: Michael Landy and Jean Tinguely*,
 ed. Laurence Sillars. Tate Gallery Liverpool,
 2 October 2009–10 January 2010, London 2009 (cat.)
– *A mancha humana / The human stain*, CGAC – Centro
 Galego de Arte Contemporánea, Santiago de Compostela,
 12 March–31 May 2009 (cat.)
– *CHHTTT... Le merveilleux dans l'art contemporain: part
 2*, ed. Pierre Alferi. Crac Alsace – Centre Rhénan d'Art
 Contemporain Alsace, Altkirch 2009 (cat.)
2008 – *Tiger in the Pocket!: 37e Internationaal Filmfestival
 Rotterdam*, Limburg 2008
2007 – Simone Neuenschwander, *Poor Thing: Karla Black, Robert
 Breer, Martin Heldstab, Knut Henrik Henriksen, Dagmar
 Heppner, Karin Hueber, Ian Kiaer, Kilian Rüthemann*.
 Kunsthalle Basel, 10 June–2 September 2007, Basel 2007
 (cat.)
– Eva Scharrer, 'Poor Thing in der Kunsthalle', in:
 Kunstbulletin, September 2007, p. 51
– *Collection art contemporain: la collection du Centre
 Pompidou, Musée National d'Art Moderne*, ed. Sophie
 Duplaix, Paris 2007 (cat.)

– *AURORA 2007. Possible Words*, ed. Adam Pugh, Norwich,
 UK, 2007 (cat.)
– Martine Valo, 'Un coup de pouce au cinéma de poche',
 in: *Le Monde,* vol. 160
– Dirk de Bruyn, 'Performing a traumatic effect: the films of
 Robert Breer' in: *Animation Studies – Animated Dialogues*
 2007, pp. 20–28
– 'Robert Breer interviewed by David Curtis', in: *Cinema
 City*, Norwich UK, 10 November 2007
– Milou Allerholm, 'Hjalp, det rör sig', in: *Dagens Nyheter,*
 3 February 2007.
– Régis Durand, *Du Machinique et du Vivant*. La Réserve,
 Pacy-sur-Eure, 7 October 2007–12 January 2008 (cat.)
2006 – *Robert Breer, Films, Floats & Panoramas*, ed. Laura
 Hoppman, Musée-Château d'Annecy, 12 April–31 August
 2006; Musée d'art Roger-Quilliot, Clermont-Ferrand,
 January–March 2007, Montreuil 2006 (monographic cat.)
– *Le mouvement des images*, ed. Philippe-Alain Michaud.
 Centre Pompidou, Musée National d'Art Moderne – Centre
 de création industrielle Paris, 9 April 2006–29 January
 2007, Paris 2006 (cat.)
– Jean-Max Colard, 'Artiste à l'œuvre inclassable, Robert
 Breer est à l'honneur cet été', in: *Les inrockuptibles*,
 vol. 549, 6 June 2006, p. 133
– Roxana Azimi, 'Vente d'artistes inclassables', in: *Le Monde*,
 11 June 2006
– Régine Rémond, 'Rober Breer au Musée du Château
 d'Annecy', in: *L'Essor Savoyard*, vol. 14, 6 April 2006
– *Willa Warszawa*, 25 August–1 September 2006, Frankfurt
 2006 (cat.)
2005 – *L'œil moteur, Art Optique et Cinétique, 1950–1975*,
 ed. Emmanuel Guigon. Musée d'Art Moderne et
 Contemporain de Strasbourg, 13 May–25 September 2005,
 Strasbourg 2005 (cat.)
– *Daumenkino – The Flip Book Show*. Kunsthalle
 Düsseldorf, 7 May–17 July 2005, Cologne 2005 (cat.)
2004 – 'Carnegie International', in: The *New York Times*,
 4 April 2004
– 'Genesis Sculpture, expérience Pommery #1', ed. Frédéric
 Morel. Domaine Pommery, Reims, 15 May–15 October 2004,
 Paris: *Beaux Arts Magazine*, 2004 (cat.)
– *54th Carnegie International 2004–5*, ed. Laura Hoptman,
 The Carnegie Museum of Art, Pittsburgh,
 9 October 2004–20 March 2005, Pittsburgh 2004 (cat.)
– *The Pontus Hultén Collection*, ed. Karl Gunnar Pontus
 Hultén and Iris Müller-Westermann. Moderna Museet
 Stockholm, 14 February–18 April 2004, Stockholm
 2004 (cat.)

– Pierre Juhasz, 'Links: gb agency', in: *Paris-Art.com*
– 'Mouvements de Fonds', in: *Les Cahiers du FNAC*,
no. 5, Centre de la Vieille Charité, M.A.C, Galeries
Contemporaines des Musées de Marseille
– Thomas Clerc, 'Slow Motion …', in: *Magazine 02*, no. 28,
winter 2003/2004
– Michael Kimmelman, 'Modernism wasn't so American
after all', in: *The New York Times*, 2 July 2004
– *Beyond Geometry: Experiments in Form, 1940s–1970s*,
ed. Lynn Zelevansky. Los Angeles County Museum of
Art, 13 June–3 October 2004; Miami Art Museum,
Florida, 18 November 2004–1 May 2005, Cambridge, MA,
2004 (cat.)
– Christopher Knight, 'A Global Cacophony', in: *Los Angeles
Times, 5 December 2004*
– *E. A. T. Exhibition*, Norrköping Museum of Art,
Norrköping, Sweden 2004 (cat.)

2003 – *ReCreation: Films by Robert Breer*, New Zealand Film
Festival (cat.)
– *New York Film Festival*, New York (booklet)
– Damien Sausset, 'Promenade … exposition Links',
in: *Art Press*, vol. 296, December 2003

2002 – Guitemie Maldonado, 'Robert Breer. gb agency',
in: *Artforum*, January 2002, p. 149
– Véronique d'Auzac de Lamartine, 'Inside the Sixties:
g.p. 1.2.3.', in: *Kunstbulletin*, July/August 2002
– *Inside the Sixties: GP 1.2.3*, le salon international de
galerie-pilotes à Lausanne, 1963, 1966, 1970 = Inside the
sixties: gp 1.2.3.; the international show of pilot galleries at
Lausanne, 1963, 1966, 1970. Musée Cantonal des Beaux-
Arts, Lausanne, 24 May–15 September 2002, Lausanne,
2002 (cat.)
– *Dessins*. Screening, Le Lieu Unique, Nantes (cat.)
– *French Collection: 49 artistes d'aujourd'hui*. Mamco –
Musée d'art moderne et contemporain Geneva,
1 November 2002 – 19 Januar 2003, *Les Cahiers du FNAC*,
vol. 2, 2002 (cat.)

2001 – *Les années Pop 1956–1968*, ed. Francis Marc. Musée
National d'Art moderne, Centre Georges Pompidou, Paris,
15 March–18 June 2001, Paris 2001 (cat.)
– Jean-Michel Bouhours, *E-motion – Hommage à Robert
Breer*, Musée National d'Art Moderne, Centre Georges
Pompidou, Paris, 10 September–5 Oktober 2001 (cat.)
– Charles-Arthur Boyer, 'Promenade … Robert Breer, gb
agency', in: *Art Press,* vol. 273, 2001
– Karyn Riegel, 'Animations: The Animated Reflex',
in: *P.S.1*, Museum of Modern Art, New York (exhibition
journal)

– Françoise-Aline Blain, 'Robert Breer, "Une armée
flottante"', in: *Beaux-Arts Magazine*, vol. 208,
September 2001
– Emmanuelle Lequeux, 'Robert Breer', in: *Aden – Le Monde*,
26 September–2 October 2001, p. 26
– Alexis Vaillant, 'ça bouge tout seul! Le livre permanent
de Robert Breer', in: *Kunstbulletin* 10, October 2001,
pp. 30–31
– *Jeune, Dure et Pure: une histoire du cinéma d'avant-garde
et expérimental en France,* ed. Nicole Brenez and Christian
Lebrat, Paris 2001

2000 – Frazer Ward, 'Robert Breer, AC Project Room', in: *Frieze
Magazine*, vol. 55, 2000, pp. 106–107
– Sid Sachs, 'Robert Breer at Staff USA', in: *Art in America*,
October 2000
– Roberta Smith, 'Robert Breer', in: *The New York Times*,
7 January 2000
– *Breer on Breer. An Evening with Robert Breer,* February 25,
Walker Art Center, Minneapolis (cat.)
– Jason Haas, 'Experimental Animator Robert Breer Comes
to Campus', in: *The Wesleyan*, 31 March 2000
– 'Virtual shows: Robert Breer Floats', in: *Documents sur l'art*,
no. 12, 2000

1999 – Jennifer Burford, *Robert Breer*, Editions Paris expérimental
et RE-Voir, Paris
– Raphaël Bassan, 'Robert Breer: un atypique de l'avant-garde',
in: *Bref Magazine*, vol. 40, Spring 1999
– Dominique Noguez, 'Eloge du cinéma expérimental',
Paris 2000
– *Kunst im Aufbruch: Abstraktion zwischen 1945 und 1959*,
ed. Richard W. Gassen. Wilhelm-Hack-Museum Ludwigs-
hafen am Rhein, 18 October 1998–31 January 1999,
Ostfildern-Ruit 1998 (cat.)
– 'Entretien entre Robert Breer et Yann Beauvais 1983',
in: *Scratch Book 83/98*, Light Cone, Paris

1998 – Lionel Bovier, *Oops: John Armleder, Francis Baudevin,
Robert Breer, Michael Scott, John Tremblay*. Magasin –
Centre National d'Art Contemporain de Grenoble,
6 June–6 September 1998; L'Elac, Espace Lausannois d'Art
Contemporain, Lausanne; Grenoble 1998 (cat.)
– Jennifer Burford, *Vers une radicalisation du mouvement et
de la continuité. Robert Breer: peintre sculpteur et cinéaste*,
Villeneuve d'Ascq, 1998

1997 – Fred Camper, 'On Visible Strings: Films by Robert Breer',
in: *Chicago Reader*, 6 June 1997
– Wheeler Winston Dixon, *The Exploding Eye. A Re-Visionary
History of 1960s American Experimental Cinema*, Albany,
N.Y. 1997

1996 – *L'art du movement:* collection cinématographique du Musée National d'Art Moderne; 1919–1996, ed. Jean-Michel Bouhours, Paris 1996

1995 – *Beat Culture and the New America 1950–1965,* ed. Lisa Phillips and Maurice Berger. Whitney Museum of American Art, New York, 9 November 1995–4 February 1996, New York 1995 (cat.).

– John Hanhardt, 'Film image, electronic image: the construction of abstraction 1960-1990', in: *Visible language,* vol. 29, no. 2, Spring 1995, pp. 138–159

1992 – Jonas Mekas, *Ciné-Journal, Un nouveau cinéma américain 1959–1971,* translation and foreword by Dominique Noguez, Paris 1992

1990 – Billy Klüver and Julie Martin, *Robert Breer, a Painter in Paris 1949–1959,* Galerie 1900–2000, Paris, 11–29 September 1990, Paris 1990 (cat.)

– *Rolf Ricke: Texte von Künstlern, Kritikern, Sammlern, Freunden und Kollegen geschrieben für Rolf Ricke aus Anlass seines 25-jährigen Galeriejubiläums,* ed. Marianne Stockebrand. Kölnischer Kunstverein, 7 November 1989–7 January 1990, Cologne 1990 (cat.)

1989 – Scott McDonald, 'But First a Little Ru-Ru: An Interview by Robert Breer – Recent films', in: *The Velvet Light Trap,* no. 24, Autumn 1989, p. 75

1988 – Gianalberto Bendazzi, *Cartoons. Il cinema d'animazione,* Venezia 1988

1987 – *Program: The Maya Deren Award for Independent Film and Video Artists,* The American Film Institute, New York 1987

– 'How much pleasure for her Majesty?', in: *The Independent,* 11 March 1987

– Katherine Dieckmann, 'Etch-a-Sketch', in: *Voice,* 6 January 1987

1986 – Chris Farlekas, 'Large ideas in small frames, Robert Breer', in: *The Times Herald Record,* 7 November 1986

1985 – 'Trial Balloons', in: *Ear Magazine,* Autumn 1985

– *1985 biennial exhibition.* Whitney Museum of American Art, New York, 13 March–9 June 1985, New York 1985 (cat.)

1984 – *The international directory of films and filmmakers,* ed. Christopher Lyon, vol. 2, London 1984

– 'Robert Breer: Five and Dime Animator', Produced by Largedoor Ltd. and Channel 4, London (Television Film)

1983 – Yann Beauvais, 'Interview with Robert Breer', in: *Scratch,* April 1983

– *Five and dime animator, a complete retrospective in context,* ICA – Institute of Contemporary Arts London, 1983 (cat.)

– *Retrospective,* Whitney Museum of American Art, New York, 1983 (cat.)

– Hollis Frampton, *Circles of Confusion: Film Photography Video Texts 1968–1980,* with a foreword by Annette Michelson, Rochester, N.Y., 1983

– 1983 biennial exhibition: painting, sculpture, photography, installations, film, video. Whitney Museum of American Art, New York, 15 March–29 May 1983, New York 1983 (cat.)

1982 – MCC Staff, 'A Man and His Dog Out for Air by Robert Breer', in: *Cinema Young Viewers,* vol. 5, Summer 1982

– Fred Camper, 'Robert Breer: Fuji, 77, LMNO and T.Z. ', in: *10 Years of Living Cinema,* ed. Kathy Dieckmann and John Pruitt, New York 1982 (cat.)

– Dominique Noguez, *30 ans de cinéma expérimental en France: 1950–1980,* Paris 1982

1981 – *1981 biennial exhibition.* Whitney Museum of American Art, New York, 20 January–19 April 1981, New York 1981 (cat.)

– Lois Mendelson, *Robert Breer: A Study of His Work in the Context of the Modernist Tradition,* Ann Arbor, Mich. 1981

1980 – Amy Taubin, 'Robert Breer, Whitney Museum', in: *Artforum,* September 1980

– Jay Hoberman, 'Robert Breer's Animated World', in: *American Film,* vol. 5, September 1980

– Sandy Moore, *Robert Breer,* Minneapolis 1980

– Jim Trainor, 'Robert Breer', in: *Upstart,* Spring 1980, pp. 16–19

– Amy Taubin, 'On a Breer Day', in: *The Soho News,* 28 May 1980

– Richard Huntington, 'Breer's Happy Images', in: *Buffalo Courier Express,* October 1980

1979 – Noel Carroll, 'The Other Cinema', in: *The Soho Weekly News,* 25 January 1979

– Dominique Noguez, *Éloge du cinéma expérimental: definitions, jalons, perspectives.* Musée National d'Art Moderne, Centre Georges Pompidou, Paris (cat.)

– Elena Pinto Simon, 'Robert Breer's LMNO', in: *Millennium Film Journal,* vol. 4/5, Summer/Autumn 1979, pp. 184–186

– *1979 biennial exhibition.* Whitney Museum of American Art, New York, 6 February–1 April 1979, New York 1979 (cat.)

– Jay Hobermann, 'A Mixed Bag Of Tricks', in: *Village Voice,* 22 January 1979

1978 – Eric Sherman, 'Robert Breer, Larry Jordan and Harry Smith', in: *Filmex,* Program of filmex-festival, Los Angeles, 1978

– P. Adams Sitney, *The Avant-Garde Film: a reader of theory and criticism,* New York 1978

1977 – Marian Keane, 'Beauty In A Gesture: The Films of Breer', in: *The Thousand Eyes Magazine,* New York 1977

– *Film als Film, 1910 bis heute: vom Animationsfilm der
20er Jahre zum Filmenvironment der 70er Jahre,* ed.
Bettina Hein and Wulf Herzogenrath. Kunstverein Köln,
24 November 1977–15 January 1978; Akademie der Künste
Berlin, 19 February–19 March 1978; Museum Folkwang
Essen, 21 April–28 May 1978; Württembergischer
Kunstverein Stuttgart, June–July 1978, Stuttgart 1977
(cat.)
– Amy Taubin, 'A Long Last Breer', in: *The Soho Weekly
News*, 14 April 1977
– *1977 biennial exhibition.* Whitney Museum of American
Art, New York, 19 February–3 April 1977, New York 1977
(cat.)
– *Paris–New York: un album.* Musée National d'Art Moderne
Centre Georges Pompidou, Paris, 1 June–19 September
1977, Paris 1977 (cat.)
– *New American filmmakers: eine Serie von Filmen und
Videobändern,* ed. John G. Hanhardt. 28. Internationale
Filmfestspiele Berlin, 8. Internationales Forum des Jungen
Films, Berlin, 24 February–3 March 1978, compiled by
Whitney Museum of American Art, New York, Berlin 1978
(cat.)
– *Melba,* vol. 2, January–February, Paris 1977

1976 – *Robert Breer, Program,* Museum of Modern Art, Film
Department
– *Une Histoire du Cinéma,* ed. Peter Kubelka. Musée
National d'Art Moderne, Centre Georges Pompidou,
Paris 1976 (cat.)
– Robert Breer, 'Notes de Paris 1949–1959', in: *Une
Histoire du Cinéma,* ed. Peter Kubelka. Musée National
d'Art Moderne, Centre Georges Pompidou, Paris
1976 (cat.)
– D.C., 'Films by Robert Breer', in: *Art+Cinema,* vol. 2, 1976
– Lucy Fischer, 'Independent Film: Talking with Robert
Breer', in: *University Film Study Newsletter,* no. 1, 1976
– Fred Camper, 'Animated Dissection', in: *The Soho Weekly
News*, 20 May 1976
– Robert Russell/Cecile Starr, *Experimental Animation:
an illustrated Anthology,* New York, 1976
– *A history of the American avant-garde cinema: a film
exhibition.* The American Federation of Art, New York
1976 (cat.)

1975 – Amos Vogel, 'The avant-garde of the seventies', i
n: *Film Comment*, vol. 11, no. 3, May–June 1975, p. 35
– Lucy Fischer, 'Avant-Garde Film (Homage to Robert
Breer)', in: *The Soho Weekly News*, 3 April 1975
– Karen Cooper, 'Films of Robert Breer', in: *Film Forum,*
27 March 1975

1974 – 'Robert Breer', *Art Report*, Summer 1974
– Scott Hammen, 'Gulls and Buoys: an Introduction to
the Remarkable Range of Pleasures Available from
the Films of Robert Breer', in: *Afterimage*, vol. 2, no. 6,
December 1974
– *New Forms in Film,* ed. Annette Michelson. Montreux,
3–24 August, Montreux 1974 (cat.)
– 'P. Adams Sitney, *Visionary Film: the American avant-
garde,* New York 1974

1973 – P. Adams Sitney/Jonas Mekas, 'An Interview with Robert
Breer', in: *Film Culture,* 56/57, Spring 1973
– Annette Michelson, 'Intellectual Cinema:
A Reconsideration', in: *Yale University Art Gallery
Catalogue*, April/May 1973
– *1973 biennial exhibition: contemporary American Art.*
Whitney Museum of American Art, New York,
10 January–18 March 1973, New York 1973 (cat.)

1972 – *Pavilion by experiments in art and technology,* ed. Billy
Klüver, Julie Martin, Barbara Rose, New York 1972

1971 – H. R., 'Robert Breer at Bonino Gallery', in: *Artnews,*
January 1971
– *VIIe Biennale des Jeunes.* Parc Floral de Paris, Bois de
Vincennes, 15 September–21 October 1971, Paris 1971 (cat.)
– *Robert Breer,* Bonino Gallery, New York 1971 (cat.)
– *1971 biennial exhibition.* Whitney Museum of American
Art, New York, 1971 (cat.)
– Carter Ratcliffe, 'New York Letter', in: *Art International,*
no. 15, January 1971
– David Curtis, *Experimental Cinema: a fifty year Evolution,*
London 1971
– Emily Genauer, *'Art and the Artists',* in: The *New York
Post,* 6 March 1971
– Alfredo Leonardi, *Occhio mio dio: il new American cinema,*
Milan 1971
– Nicolas and Elena Calas, *Icons and Images of the Sixties,*
New York 1971

1970 – Calvin Tomkins, 'Onward and Upward with the Arts:
E.A.T.' in: *The New Yorker*, 14 November 1970
– *Robert Breer: 93 Floats,* Bonino Gallery, New York,
10 November–5 December 1970, New York 1970 (cat.)
– *Kinetics,* Hayward Gallery, London,
20 September–22 November 1970, London 1970 (cat.)
– *Expo'70,* ed. E.A.T. (Experiments in Art and Technology),
Pepsi-Cola-Pavilion, World Expo, Osaka (cat.)
– 'Robert Breer to be shown in Museum Garden',
in: *The Museum of Modern Art*, New York, 25 August 1970
– Donald Richie, 'Cineprobe', in: *The Museum of Modern
Art*, New York, 6 October 1970

1969 – Jonas Mekas, 'Movie Journal', in: *The Village Voice*,
24 April 1969
– Pontus Hultén, *The Machine as Seen at the End of the
Mechanical Age*, Museum of Modern Art, New York, 25
November 1968–9 February 1969; San Francisco Museum
of Modern Art, 23 June–24 August 1969, New York 1968
(cat.)
– Michael Kirby, *Art of Time: Essays on the avantgarde*,
New York 1969
– *Description of the Pepsi-Cola Pavilion for the Japan World
Exhibition 1970, Osaka*, New York 1969

1968 – Michael Kirby, 'The Experience of Kinesis', in: *Art News*
66, February 1968, pp. 42-45
– 'Erlösung vom Sockel', in: *Der Spiegel* 12, 18 March 1968,
pp. 179–180
– *Robert Breer*, Galerie Ricke Köln, 6 March–6 April 1968,
Cologne 1968 (cat.)
– *Das Modern-Art-Museum München zeigt neue Kunst
USA: Barock-Minima*, ed. Christian Diener. Modern Art
Museum, München 1968 (cat.)
– Elodie Osborne, 'The Young Film-maker', in: *Art in
America*, January/February 1968
– Gregory Battcock, *Minimal Art: A Critical Anthology*,
New York 1968

1967 – Harris Rosenstein, 'Motionless Motion', in: *Art News*,
November 1967
– *Robert Breer: More Floats*, Bonino Gallery, New York,
14 November–9 December 1967, New York 1967 (cat.)
– *Exchange Show*, Museum of Modern Art, New York; Tokyo
Museum of Modern Art, Tokyo, 1967 (cat.)
– Nan Rosenthal Piene, 'Light Art', in: *Art in America* 55, 3,
May/June 1967
– Adrienne Mancia and Willard Van Dyke, 'Four Artists as
Filmmakers', in: *Art in America* 55, 1, January/February
1967, pp. 64–73
– Gregory Battcock (ed.), *The new American cinema:
a critical anthology*, New York 1967
– Ralph Stephenson, *Animation in the Cinema*, London 1967
– Sheldon Renan, *An Introduction to the American
Underground Film*, New York 1967
– Sheldon Renan, *The Underground Film: an introduction
to its development in America*, London 1967
– *Kinetic And Programmed Art*. Rhode Island School of
Design, Museum of Art, Providence 1967 (cat.)

1966 – Grace Glueck, 'A Wet Moore, a dry Armada',
in: The *New York Times*, 20 February 1966
– *Robert Breer: Floats*, Bonino Gallery, New York
1966 (cat.)

– Annette Michelson, 'Film and Radical Aspirations',
in: *Film Culture*, no. 42, Autumn 1966, pp. 34–42
– William Berkson, 'Breer at Bonino Gallery, A Review',
in: *Arts* 40, April 1966
– Richard Dyer Mc Cann, *Film: A Montage of Theories*,
New York 1966

1965 – Dore Ashton, 'The Non-Rational Tradition in Modern Art',
in: *Studio International* 169, April 1965
– Donald Judd, 'Breer at Bonino Gallery', in: *Arts* 39,
February 1965
– Alan Solomon, *Robert Breer, Constructions and Films*.
Bonino Gallery, New York, 12 January–6 February
1965 (cat.)

1964 – *Les Cahiers du Cinéma*, Feb. 1964
– 'The Animals in New York: Keep on Truckin Mama',
in: *The Village Voice*, 17 September 1964
– Sally Kempton, *Truckin my Blues Away*, 1964
– Robert Benayoun, 'The Phoenix and The Roadrunner',
in: *Film Quarterly* 17, 3, Spring 1964, pp. 17–25

1963 – André S. Labarthe, 'Le Festival d'Annecy', in: *Les Cahiers
du Cinéma* 147, September 1963
– 'A Statement, Robert Breer', in: *Film Culture*, no. 29,
Summer 1963
– Guy L. Coté, 'Une Nouvelle Notion de Continuité:
Entretien avec Robert Breer', in: *Positif*, vol. 54/55,
July–August 1963

1962 – Robert Breer, 'What Happened?', in: *Film Culture*, no. 26,
Autumn 1962
– Guy L. Coté, 'Interview with Robert Breer', in: *Film
Culture*, no. 27, Winter 1962, pp. 17–20
– *Art 1963: a new vocabulary*, ed. Annice Kandell and
Billy Klüver. Philadelphia Arts Council of the
YM/YWHA, 25 October–7 November 1962, Philadelphia
1962 (cat.)

1961 – Robert Breer, in: *Film Quarterly* 14, 4, Summer 1961
– 'Interview with Robert Breer. One Two Films', in: *Film
Culture*, no. 22/23, Summer 1961
– Noel Burch, 'Images by Images, Cats, Jamestown Balooes,
A Man and His Dog Out For Air. Films by Robert Breer',
in: *Film Quarterly* 12, 3, Spring 1959

1958 – 'Libre Cinéma', in: *Journal Radio Television Cinéma*, Paris,
March 1958

1957 – Robert Breer, 'Images in Motion, a painter's note on
cinema', in: *The Louisvillian* 1, 2, November 1957

1956 – Paul Davay, *Ecran du seminaire des arts, Séance du 31
janvier*, Palais des Beaux-Arts de Bruxelles, Brussels 1956
– Barbara Butler, 'Art and Artists', in: *The New York Herald
Tribune* (Paris edition), 24 October 1956

– Michel Seuphor, 'Robert Breer', in: *The American Students'
 and Art Center*, October 1956 (cat.)

– R. V. Gindertael, 'Brussels: Palais des Beaux Arts',
 in: *Les Beaux Arts*, 1 January 1956

1955 – R. V. Gindertael, 'A la Galerie "Aujourd'hui" Robert Breer',
 in: *Journal*, Paris

– *Le Mouvement: Agam, Bury, Calder, Marcel Duchamp,
 Jacobsen, Soto, Tinguely, Vasarely*. Galerie Denise René,
 Paris, 6–30 April 1955, Paris 1955 (cat.)

1954 – Pontus Hultén, *Baertling, Bitran, Breer*. Galerie Denise René,
 Paris 1954 (cat.)

– 'Exposition Baertling, Bitran, Breer', in: *The New York
 Herald Tribune*, 26 February 1954

– 'Exposition Baertling, Bitran, Breer', in: *Profils*, no. 7, 1954

1953 – J. S., 'Accrochages chez Denise René', in: *Arts*, 24 July 1953

– Frank Edgar, 'La flambée d'art abstrait sur quoi se termine la
 saison ajoute l'imposture à l'inéxperience', in: *Carrefour*,
 2 July 1953

– 'Denise René', in: *Combat*, 30 August 1953

– Huitième *Salon des Réalités Nouvelles*. Musée des beaux-arts
 de la ville de Paris, 10 July–9 August 1953, Paris 1953 (cat.)

1952 – 'Exposition 7, Galerie Denise René', in: *The New York Herald
 Tribune* (Paris edition), 26 February 1952

Time line for the film *A Frog on the Swing*, 1989 (details)
Coloured pencil and felt-pen on paper, 27.8 x 21.5 cm / 21.5 x 27.8 cm

Breer timeline chart (handwritten, Page 2 of 2)

Scene • Lost Frames	frames to left	edge # (2 Frames)	frames to rt.	subject	BIN #
59	15	J2 34617	12	(sketch)	27
60	← 9 →			(sketch) brown	27
61	0	J2 8 59993	6	same as above	28
62	4	J2 31 55179 + 86	3	lines swinging horizon	28
63	1	07 58427 432	16		29
64	10	J2 8 59995	6		29
65	1	J2 31 55187 193	14 (13)	live	30
66	-1 (-2)	J2 07 58433 494	2		30
67	3	58411 413	3		31
68	18	J2 07 58416 422	0		31
69	14	J2 07 58414	15		32
70	9	J2 69 86601 603	-1		32
71	17	58457 460	17		33
72	18	J2 31 55290 292	7		33
73	7(6)	J2 31 55284 285	1 (12)		34
74	5	69 86613 614	14		34
75	18	J2 69 86576	12		35
76	11	J2 31 55300	8	power	35
77	10	J2 31 55286 287	11		36
78	0	86642 645	3		36
79	-1	55269 271	8	cop	37
80	← 21 →			Black	37
81	-1	J2 07 58355 358	7	heli cpt	37
82	14	58347 350	5		37
83	← 50 →			Black	
84	5	58476 482	1		38

Scene	frames to left	edge # 2 frames	frames to rt.	subject	BIN #
88	3(2)	58294 297	0(1)		39
89	4	58483	13		40
90	← 6 →				40
91	15	86525 529	4		41
92	8	55275	5		41
93	17	58473 475	16		42
94	16	86522	9		42
95	16	86646	18 (17)		43
96	14	58467	2		43
97	8	86557 561	0		44
98	4	86523	2		44
99	← 16 →				45
100	12	55265	11		45
101	15	86655 659	4		46
102	← 76 →			black	
103	16	86704 708	7	live trees	46
104	← 33 →			black	
105	17	86535 543	9 (8)		47
106	16	86651	7		47
107	14 (13)	86653 654	16		48
108	2(1)	86550 556	1		48
109	9	86529 534	3(2)		49
110	← 30 →			black	
111	0(w)	55313 315	2(1)		50
112	← 41 →			black	
113	3	34643 651	0		51

Breer wrote this timeline after completion of the film.
It is the only one which exists from one of his films.

This publication is published to accompany the exhibition: *Robert Breer*

11 June to 25 September 2011, BALTIC Centre for Contemporary Art, Gateshead

26 October 2011 to 29 January 2012, Museum Tinguely, Basel

Exhibition BALTIC

Director: Godfrey Worsdale
Exhibition Curator: Laurence Sillars
Assistant Curator: Katharine Welsh
Registrar: Laura Harrington
Technical Management: Chris Osborne & Ian Watson
Communications: Ann Cooper
Learning: Emma Thomas
Development: Aerian Rogers
Finance & Resources: Stephen Cleland
Building Services: James Johnson

BALTIC Centre for Contemporary Art
Gateshead Quays, South Shore Road, Gateshead, NE8 3BA, UK
Tel. +44 0 191 478 18 10, Fax: + 44 0 191 478 19 22
info@balticmill.com, www.balticmill.com

Exhibition Museum Tinguely

Director: Roland Wetzel
Exhibition Curator: Andres Pardey
Registrar: Daniel Boos
Restauration & Conservation: Reinhard Bek, Jean-Marc Gaillard, Didier Warin
Technical Services: Urs Biedert
Public Relations: Isabelle Beilfuss
Educational Services: Beat Klein, Lilian Steinle-Schmidt
Office: Sylvia Grillon, Katrin Zurbrügg

Museum Tinguely
Paul Sacher-Anlage 2, Postfach 3255, CH-4002 Basel
Tel. +41 61 681 93 20, Fax: +41 61 681 93 21
infos@tinguely.ch, www.tinguely.ch

Catalogue

Editorial staff: Andres Pardey
Translations: Eva Dewes, Petra Ledolter, Susan Ring, Carola Wark
Copyediting: Sarah Quigley
Project Management Kerber Verlag: Katrin Günther
Design: Susanne Bax

Front side cover illustration: *Ohne Titel*, 1972; Graphite on paper; 28 x 21.7 cm. Back side cover illustration: *Floats*, 1965

Photo credits: Bram Belloni: 82, 83 (© 2008); Eric Boutin: 151; Frances Breer: Back Cover; Robert Breer: 153; Colin Davison, BALTIC Centre for Contemporary Art: 11, 14, 15, 17, 18, 19, 32; Marc Domage: 12, 13, 21, 31, 33, 37, 38, 39, 41, 42, 43, 80, 81, 84, 85, 116, 117 bottom; Yoann Gourmel: 87; Solène Guillier: 79; Robert A. Haller: 96; Jenny Mary: 147; Magalie Meunier: 86; Aurélien Mole: 89, 91, 93, 94, 95, 97, 98, 99, 105, 106, 108/109, 110/111, 121, 122/123, 125, 126, 127, 128/129, 132, 133, 138/139, 141, 142, 143; Peter Moore: 4, 92, 136, 137, 150 top left and right, bottom left; Hans Namuth: 150 bottom right; Nora Rupp, Musée cantonal des Beaux-Arts, Lausanne: 35; Shunk-Kender (Lichtenstein Foundation): 113, 114, 118, 119, 156; Roland Wetzel: 148; Unknown photographers: 115, 117 top, 131, 154

The Deutsche Nationalbibliothek lists this publication in the Deutsche Nationalbibliografie; detailed bibliographic data are available in the Internet at http://dnb.d-nb.de.

Printed and published by: Kerber Verlag, Bielefeld
Windelsbleicher Str. 166–170, 33659 Bielefeld, Germany
Tel. +49 (0) 5 21/9 50 08-10, Fax +49 (0) 5 21/9 50 08-88
info@kerberverlag.com, www.kerberverlag.com

Kerber, US Distribution: D.A.P., Distributed Art Publishers, Inc.
155 Sixth Avenue, 2nd Floor, New York, NY 10013
Tel. +1 212 6 27 19 99, Fax +1 212 6 27 94 84
Kerber publications are available in all good bookshops worldwide (distributed in Europe, Asia, South and North America).

German Edition: ISBN 978-3-86678-530-4

English Edition: ISBN 978-3-86678-531-1

EXCAT

Printed in Germany

709.2 BRE